IMAGES
of America

HADDON TOWNSHIP

ON THE COVER: The American Legion Band is shown on Reeve Avenue around 1925 to 1930. The Allen Irvin Morgan American Legion Post 230 had it headquarters at 9 Reeve Avenue from the 1920s until late in the 20th century. (Courtesy of William C. McKenna.)

IMAGES
of America

HADDON TOWNSHIP

William B. Brahms and
Sandra White-Grear with the
Haddon Township Historical Society

ARCADIA
PUBLISHING

Copyright © 2011 by William B. Brahms and Sandra White-Grear with the Haddon Township
 Historical Society
ISBN 978-0-7385-7650-3

Published by Arcadia Publishing
Charleston, South Carolina

Printed in the United States of America

Library of Congress Control Number: 2011928489

For all general information, please contact Arcadia Publishing:
Telephone 843-853-2070
Fax 843-853-0044
E-mail sales@arcadiapublishing.com
For customer service and orders:
Toll-Free 1-888-313-2665

Visit us on the Internet at www.arcadiapublishing.com

To the people of Haddon Township—past, present, and future

CONTENTS

Acknowledgments 6

Introduction 7

1. Streets and Homes 9

2. Education 39

3. Transportation 57

4. Business and Industry 67

5. Recreation and Entertainment 91

6. Community 111

7. Churches 123

ACKNOWLEDGMENTS

Our special thanks to Jay Grear, husband of Sandra White-Grear, and the Brahms family, whose patience, love, and encouragement helped us bring this project to completion.

This book was truly a community project. Many individuals generously allowed us to use photographs from their personal collections, assisted in gathering information, and supported us throughout this project. We are also very grateful for the support we received from the following collectors and institutions: William C. McKenna, Cliff Brunker, Paul W. Schopp, the William G. Rohrer Memorial Library branch of the Camden County Library System, the Collingswood Public Library, Lake County Discovery Museum Curt Teich Postcard Archives, the Historical Society of Haddonfield, the Gloucester County Historical Society, the Camden County Historical Society, and the West Jersey Chapter of the National Railway Historical Society. We also received very generous support from Mark Zeigler, Ken Roberts, and the *Retrospect* newspaper—publisher Brett Ainsworth helped us collect images and promote the work of the Haddon Township Historical Society. Our thanks also go to Haddon Township public officials and employees, including Mayor Randy Teague, Denise Adams, the Westmont Volunteer Fire Company, chief of police Mark Cavallo, and officer Kirk Earney.

This pictorial history would not have been possible if it were not for the many wonderful images created over the years by early local photographers, such as Milton R. Holmes, Ernest J. Fox, Don Hughes, Paul F. Beckley, Francis Stein, Jackson F. Mormann, Rowland G. King, Alfred Dotts, Andrew Scheeler, and Russell T. Homan Jr.

We would also like to thank Haddon Township's Carol Sweeney of Custom Photo Services for her expert handling and scanning of many delicate and important photographs used in this book. Our profound gratitude also goes to Haddon Township Historical Society cochairman Dennis Raible, whose research of early Haddon Township history was used extensively to create the supporting captions in this book. And, finally, a very special acknowledgment goes to the late Marguerite Bennett, who, through her careful collection of early Haddon Township photographs, demonstrated her understanding of the importance of preserving and sharing the rich history of Haddon Township.

INTRODUCTION

The documented history of Haddon Township, New Jersey, can be traced to the 1680s when Quakers settled on the banks of Newton Creek and, later, Cooper's Creek (present-day Cooper River). In 1684, the Newton Meetinghouse was built in what is today the West Collingswood Extension of Haddon Township. In 1686, Gloucester County was organized, and in 1694, the county was divided into townships, including Newton Township, which became part of the newly formed Camden County in 1844. In February 1865, a portion of Newton Township split off to incorporate as Haddon Township. The Haddon Township of 1865 was much different than it is now because it included land that is now in today's boroughs of Audubon, Audubon Park, Collingswood, Gloucester Heights, Oaklyn, Woodlynne, most of Haddonfield, and portions of Camden (Fairview section) and Haddon Heights.

In the 1800s, a cluster of houses and shops along the old road that became Haddon Avenue was called Rowandtown, named for early settler John Rowand. Rowandtown was briefly changed to Glenwood, and by 1884, it became the village of Westmont in the township of Haddon. The name Westmont was taken from a champion racehorse.

With its close proximity to Philadelphia and the industries of Camden, Haddon Township served as both quiet summer retreat and year-round residence for several wealthy industrialists and professionals. These included glass manufacturer John Mickle Whitall and Samuel Vaughan Merrick, first president of the Pennsylvania Railroad and founder of the Franklin Institute. The growth and appeal of Haddon Township to the average citizen was enhanced by its position along the rail lines, which offered services to the cities and seashore. Trolley service and, later, commuter bus service along Haddon Avenue made Haddon Township ideally situated to grow and flourish.

Crystal Lake, formerly known as Stoy's Pond, served as a destination for the poet Walt Whitman, who traveled from his home in Camden and used the Stoy's rowboat for a day's relaxation. The lake has since grown from a quiet millpond to a community swimming spot. Today, it includes a state-of-the-art swimming facility. Haddon Township has many historical thoroughfares, including several turnpikes. One of them, Haddon Avenue, was formerly known as the Haddonfield-Camden Turnpike. A tollgate located near present-day Crystal Lake Avenue served as a means of collecting monies to finance road maintenance, as well as controlling the steady traffic of merchants and farmers delivering their goods along this important roadway. By the 1920s, trolley tracks, small businesses, and stately homes lined Haddon Avenue. The homes gave way to businesses as the population moved beyond Haddon Avenue. Residents built their dream homes on the many tree-lined streets of Haddon Township, adopting the quaint neighborhood names of Bettlewood, Bluebird, Emerald Hills, and Haddonleigh. Though never a densely populated area in the 1800s, several early houses—including those belonging to the Stoy, Webster, Bettle, Reeve, Hampton, and Hopkins families—still stand today as reminders of the past.

As suburban Haddon Township grew, so did the increased needs for modern educational facilities. Education in Haddon Township began with simple schoolhouses like the Champion School (1821) and an early Rowandtown frame schoolhouse (1825), which progressed to the two-storied Rowandtown (later Westmont) schoolhouse (1872) and then the stately brick Westmont (also known as Haddon Avenue) School (1908). In the 1920s, three new elementary schools—Strawbridge Avenue, Bettlewood (later Clyde S. Jennings), and James Stoy—were added, followed in 1930 by Thomas Alva Edison (then a junior high school), and Holy Saviour parochial school. Van Sciver School and Haddon Township Junior High School were erected in the 1950s. In the 1960s, the junior high school was expanded to a junior-senior high school, and the parochial Paul VI high school was built. Most recently, William G. Rohrer Middle School was completed in 2003.

Haddon Township's history also includes several distinctive entertainment and dining establishments, from the historic vaudeville-era Westmont, Crescent, and Ritz Theatres to classic, chrome-clad Jersey diners, Green Valley Farm Dairy Bar, Compton's Log Cabin, Chubby's Restaurant, Rexy's, and more.

Volunteer and community-based service has always been an important component of living in Haddon Township. This book highlights the lives of those who serve in the community, with images of firefighters, police, teachers, volunteers, and public officials who, along with proud residents, truly epitomize the Haddon Township motto "Where Community Thrives."

One

STREETS AND HOMES

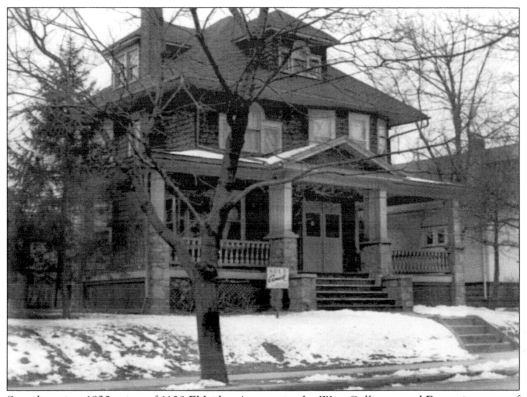

Seen here is a 1930s view of 1108 Eldridge Avenue in the West Collingswood Extension area of Haddon Township. (Courtesy of Patricia Noon.)

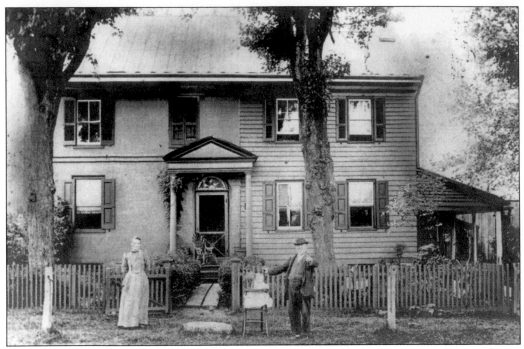

The Stoy house, located at what is now 330 Westmont Avenue, was built in two sections, as shown in the above undated photograph. The earlier section was built in the late 1700s, and an 1836 addition was completed by the Stoy family. James R. Stoy acquired the Crystal Lake Plantation in 1828. Along with farming, the Stoy family operated a sawmill (on the west side of Crystal Lake) and a flax mill (on the east side of Crystal Lake). The flax mill was destroyed by fire in 1895. John Stoy, owner of the house after his father's death in 1842, was originator of the petition to separate Haddon Township from Newton Township in 1865. The mid-20th–century photograph below shows the house with stucco exterior added. (Both, courtesy of Nancy Mathers.)

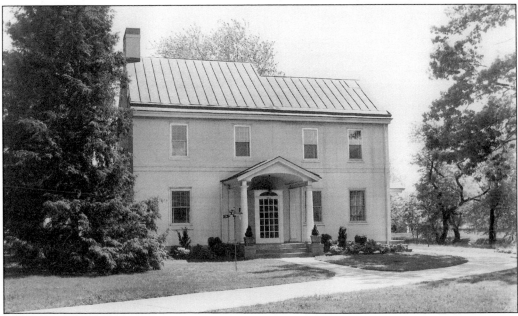

ADMINISTRATOR'S SALE
OF
Stocks & Vessel.

To be Sold at Public Vendue,

On WEDNESDAY, 26th Inst., at Elwell's Hotel, Camden, N. J., the following

SHARES OF BANK AND FERRY COMPANY STOCK AND WOOD FLAT,

Late the property of James Stoy, deceased, Viz:

Five Shares of the *Capital Stock* of "The State Bank at Camden," N. J.

Thirty-five shares of the *Capital Stock* of "The Camden and Philadelphia Steam Boat Ferry Company."

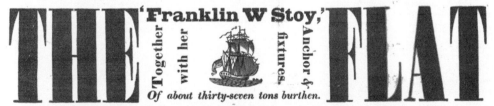

THE 'Franklin W Stoy,' FLAT
Together with her Anchor & fixtures.

Of about thirty-seven tons burthen.

She is nearly new, having been built in 1842, and is now in good order for running.

This sale is without reserve, to close the Estate, and offers a good opportunity to purchasers for property which is daily enhancing in value.

Sale to begin at 3 o'clock, P. M. Attendance and conditions, and all necessary information given, by

JACOB L. ROWAND,
JOSEPH C. STOY,

Administrators.

Newton township, July 14, 1843.

Printed by P. J. Gray, at the Office of the "Camden Mail," adjoining Cake's Ferry.

This broadside advertises an auction on July 26, 1843, of shares of stock and a boat from the estate of James Stoy. When James R. Stoy died in 1842, his estate was divided among his three children, John, Elizabeth, and Aaron. The 37-ton boat named the *Franklin W. Stoy,* referred to as a flat, was a common mode of transport along Cooper's Creek. (Courtesy of Historical Society of Haddonfield.)

In the 1800s, Crystal Lake Avenue was named Stoy's Mill Road for the sawmill on the John Stoy property. The photograph above was taken sometime around 1915 to 1920, and by then, the mill had ceased operations. The body of water to the right is Crystal Lake. The houses in view on the far right appear to be those that once stood on Stoy Avenue, most of which were demolished to accommodate the parking lot for the PATCO Hi-Speed Line. The photograph below offers a 1915–1920 view of Crystal Lake and the backs of houses 310 (with hip roof) and 312 on Westmont Avenue. The Stoy house can be seen on the right. (Above, courtesy of William B. Brahms; below, courtesy of William G. Rohrer Memorial Library, Camden County Library System.)

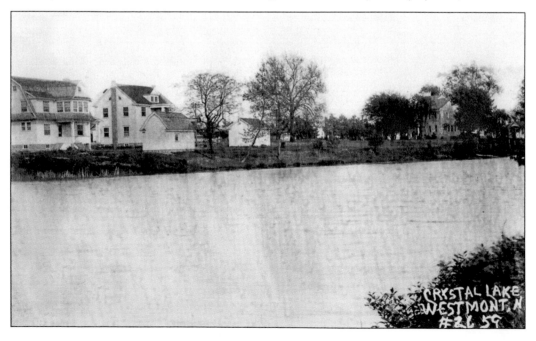

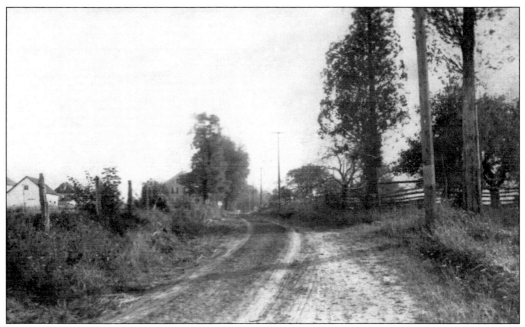

This c. 1910–1920 photograph of Crystal Lake Road above Park Avenue illustrates the rural nature of early Haddon Township. This stretch of road was near Stoy family properties and where the Haddon Hills Apartment complex was built in the 1940s. (Courtesy of William G. Rohrer Memorial Library, Camden County Library System.)

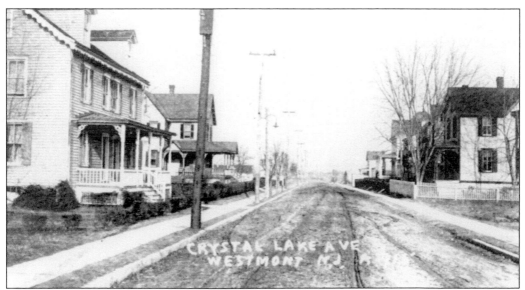

An East Crystal Lake Avenue view from Haddon Avenue around 1915 to 1920 shows houses, from left to right, 7, 9, and 13 East Crystal Lake Avenue on the left and 12 East Crystal Lake Avenue on the right. (Courtesy of Collingswood Public Library.)

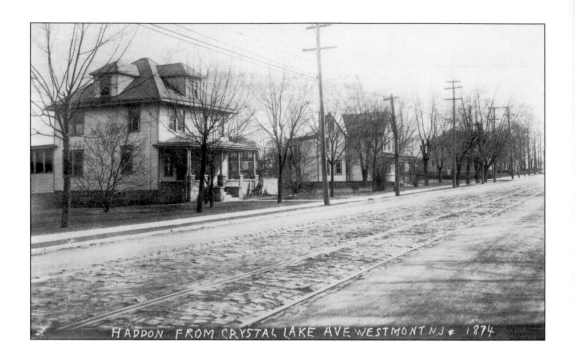

Seen above from Crystal Lake Avenue is Haddon Avenue as it appeared about 1915 to 1920, looking east. This section of Haddon Avenue was largely residential until about the mid-20th century when gasoline service stations and small pockets of businesses were built to meet the needs of the increasing use of the automobile. The image below looks west in the direction of today's Glenwood Avenue. Small stores and residences occupied this section of Haddon Avenue. On the left where the truck is parked was the site of the Haddonfield-Camden Turnpike tollgate. Trolley service began in 1895. (Above, courtesy of Anne and Boyd Hitchner; below, courtesy of Collingswood Public Library.)

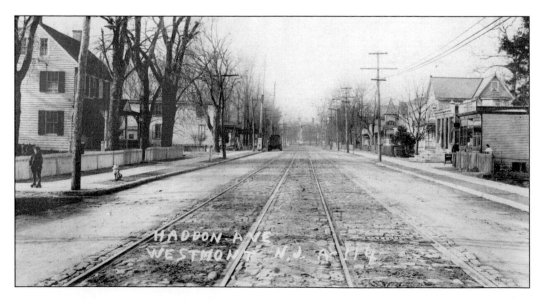

The Edward H. Cutler Company was a local real estate enterprise in the early 20th century. Beginning about 1916, Cutler's Westmont office was located on Haddon Avenue near Crystal Lake Avenue. Crystal Lake Park homes were built on old Stoy land in the vicinity of Westmont Avenue from near Stoy Avenue west to near Norwood Avenue. (Courtesy of William B. Brahms.)

John R. White elected to build his own home at 219 Norwood Avenue in 1952. As shown below, John and Rita White chose the Woodlawn model of precut houses supplied by Liberty Homes of Bay City, Michigan. Structural parts were shipped by rail, including approximately 10,000 numbered pieces of lumber, kegs of nails, hardware, and architectural drawings. The White family moved into their new house in 1953. (Courtesy of Sandra White-Grear.)

Crystal Lake Park

WESTMONT, NEW JERSEY.

The Choicest Location for Your Home

Absolutely the Largest and Lowest Priced Lots
in Camden County

Lots 40 x 160, $250.00 up

High, dry healthy location with 6000 feet frontage on Westmont Avenue or the Boulevard
A FACT: It is now cheaper to build your own home than it is to buy an
old house at the present high prices

No twin houses. Plenty of old shade. Modern City Convenience
At the Station--Close to Trolley--One Fare

You can not afford to miss seeing this property when you are considering the location for your home

LET US BUILD FOR YOU

(See description and prices on back page)

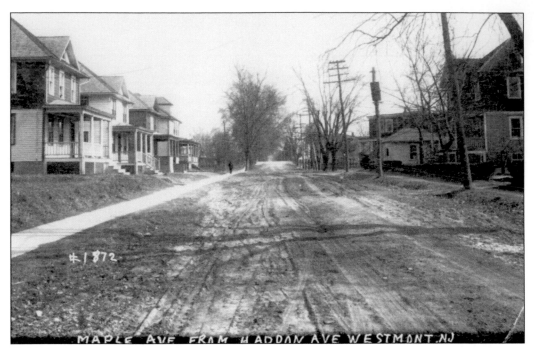

Both images seen here are of Maple Avenue, near the bridge, as it appeared around 1915 to 1920. The photograph above was taken from Haddon Avenue. Houses on the left are (from left to right) 3, 7, and 25 Maple Avenue. On the right is 6 Maple Avenue, and just before the bridge is 14 Maple Avenue. The photograph below was taken from the railroad bridge. On the left are (from left to right) 401, 407, and 409 (a new house now stands on this site) Maple Avenue. The fence and farmland on the right delineates the property line of the Samuel Wood farm. The Wood farm was a 130-acre Haddonfield property. (Both, courtesy of Collingswood Public Library.)

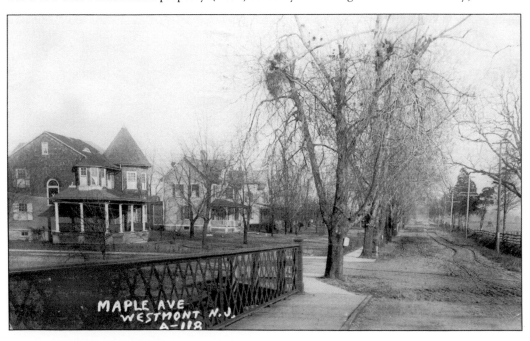

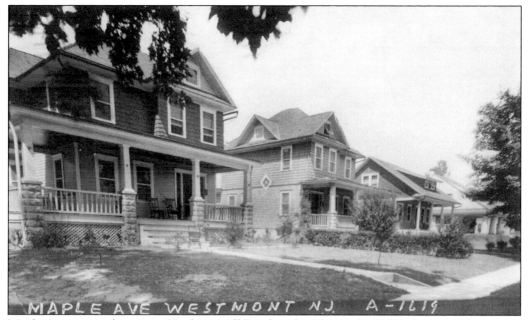

Maple Avenue was known as Hopkins Mill Road in the 1870s. John E. Hopkins, a 19th-century Haddonfield farmer, operated a gristmill near a pond on his property located at the Haddonfield end of Maple Avenue. The houses in this c. 1915–1920 photograph are (from left to right) 421, 423, 425 (a new house now stands on this site), and 427 (with columns) Maple Avenue. (Courtesy of Collingswood Public Library.)

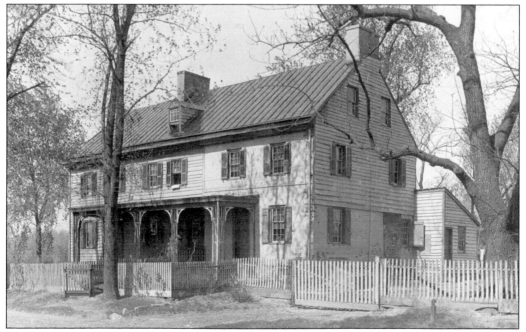

This is the Jacob Stokes Coles house, at 523 Coles Landing Road, as it looked in 1909. The Coles 70-acre property was within today's Haddon Township, and the house was within modern Haddonfield boundaries. The house was demolished in the 1990s. (Courtesy of Historical Society of Haddonfield.)

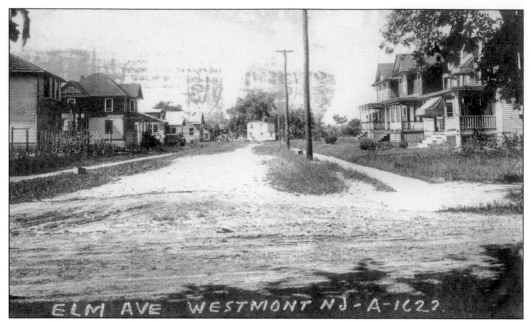

Here is Elm Avenue as it appeared in about 1920 to 1925. The houses on the right are (from left to right) 16, 14, and 12 Elm Avenue. Houses on the left are (from left to right) 9, 11, 17, 21, and 27 Elm Avenue. The house at the end of the block, facing Locust Street, is 30 Locust Avenue. (Courtesy of Collingswood Public Library.)

There were once tennis courts at what is now the 50–60 block of Melrose Avenue. (Courtesy of William C. McKenna.)

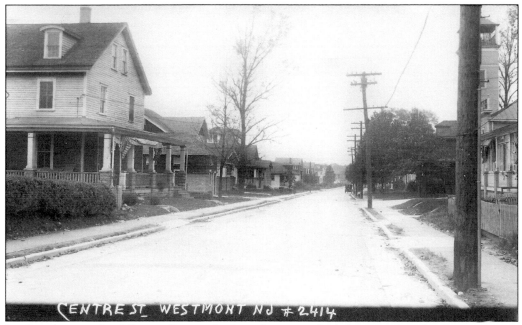

In this photograph of Center Street, the large house on the left is now 7 and 9 Center Street, followed by, left to right, 11, 17, 19, and 25 Center Street. On the right, partially hidden by trees, is 14 Center Street. (Courtesy of Stan Sheaffer.)

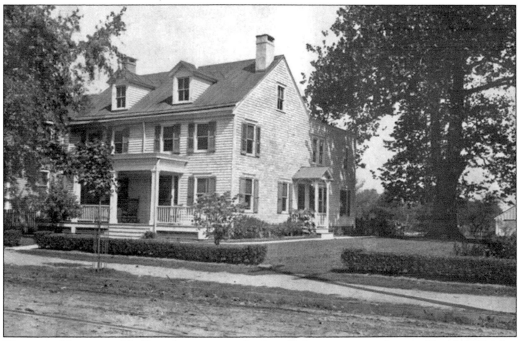

This grand house on Haddon Avenue was the late-19th–century residence of Jacob P. Fowler, Haddonfield hardware merchant and justice of the peace. Fowler's son William was one of the founding members of the Westmont Fire Company. Before its recent demolition, the building was used as the B-Thrifty Shop, a resale store run by a local hospital auxiliary. (Courtesy of William G. Rohrer Memorial Library, Camden County Library System.)

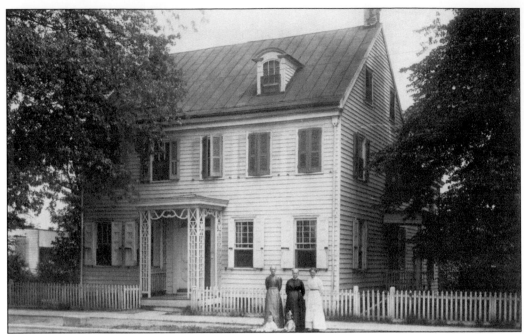

The Reeve house, as seen in this 1912 photograph, was constructed in 1838 and sold in the 1840s to Samuel A. Reeve and Lilpah White Reeve. It originally stood at 131 Haddon Avenue. In 1933, the house was moved back on the Reeve property, changing its address to 5 Reeve Avenue. (Courtesy of William G. Rohrer Memorial Library, Camden County Library System.)

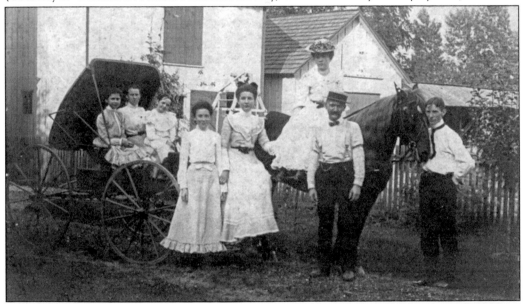

This photograph shows the rear yard of the James and Elizabeth McLaughlin residence on Haddon Avenue about 1900. In 1895, the residence is described as being on the east side of Haddon Avenue, two doors north of the tollgate. From left to right are Miriam Rudderow, Elizabeth McLaughlin, Halley Nolan, Bessie Rudderow, Matilda McLaughlin, Clara Nolan (on horse), James McLaughlin, and Esterbrook Reeve. (Courtesy of William G. Rohrer Memorial Library, Camden County Library System.)

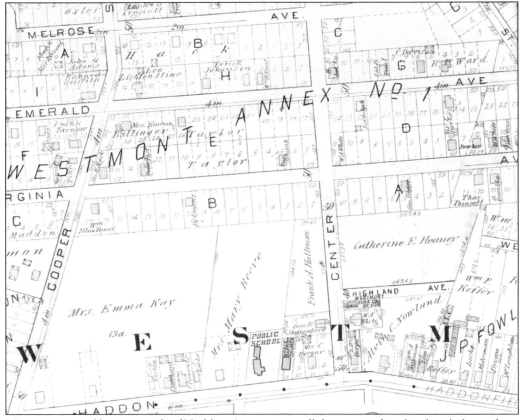

Many streets and houses north of Haddon Avenue are well documented in this detailed map from 1907. (Courtesy of William B. Brahms.)

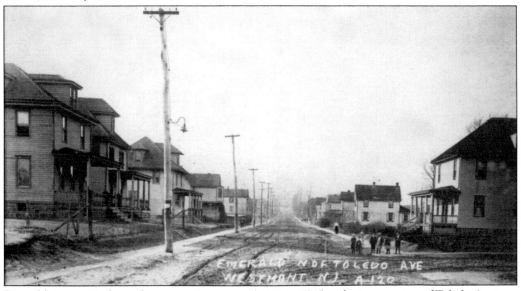

Emerald Avenue is shown here sometime around 1910 to 1915 at the intersection of Toledo Avenue. The houses on the right are 227 (right) and 229 Emerald Avenue. The houses visible on the left are, left to right, 230, 228, and 224 Emerald Avenue. (Courtesy of Paul W. Schopp Collections.)

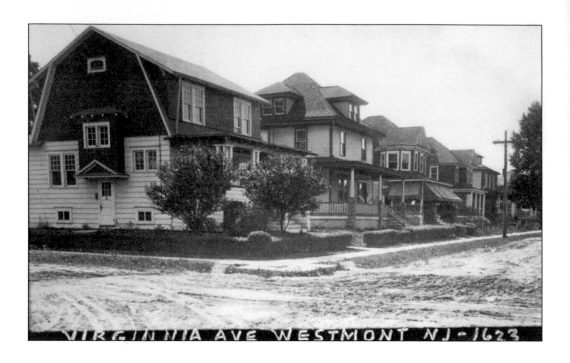

These are two 1915–1925 views of Virginia Avenue at the intersection of Center Street. The above photograph shows houses, left to right, 132, 130, 128, 126, and 124–122. The photograph below shows houses, left to right, 125, 127, 129, and 131. (Above, courtesy of William C. McKenna; below, courtesy of William G. Rohrer Memorial Library, Camden County Library System.)

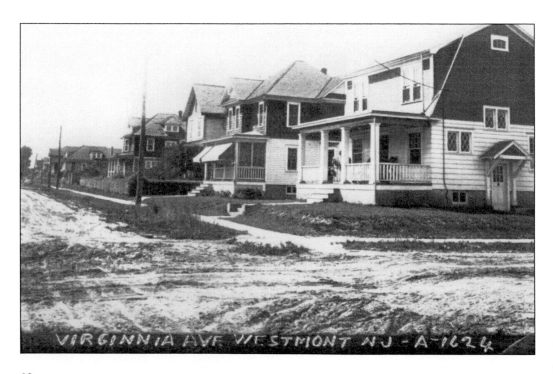

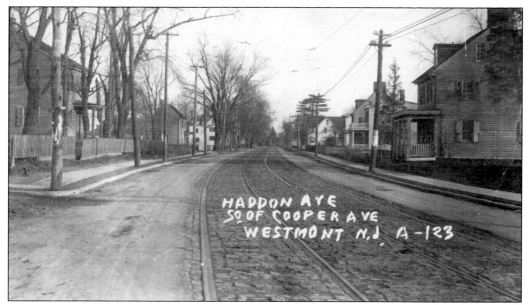

Here is a view of Haddon Avenue, south of Cooper Street, as it appeared around 1915 to 1920. The intersection of Cooper Street is visible on the left. A small sign attached to the pole on the left identifies it as Willis Lane, the street name before it was changed to Cooper Street. (Courtesy of Collingswood Public Library.)

This is Strawbridge Avenue near the corner of Oriental Avenue in about 1925. (Courtesy of William G. Rohrer Memorial Library, Camden County Library System.)

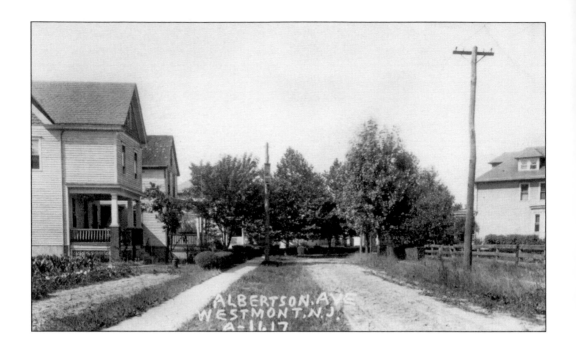

These two views of Albertson Avenue were taken sometime about 1920 to 1925. Albertson Avenue takes its name from blacksmith David Albertson, whose shop was near today's West Albertson Avenue, and his brother Thomas Albertson, who maintained his wheelwright on the opposite side of the Haddonfield-Camden Turnpike. (Both, courtesy of William G. Rohrer Memorial Library, Camden County Library System.)

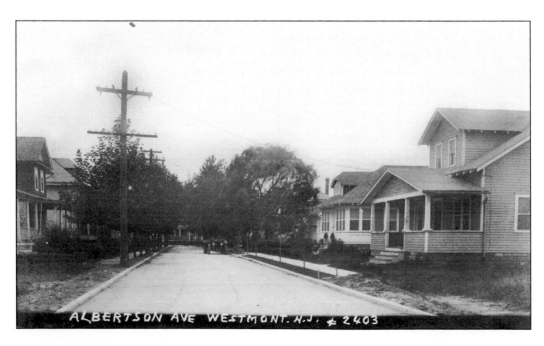

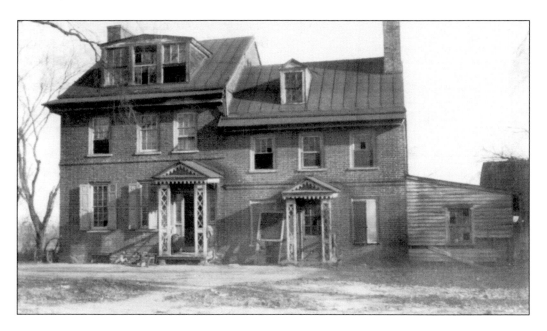

Above is a 1923 view of the Ebenezer Hopkins house, later known as the Hopkins-Burr house, when it was in a state of disrepair. Ann Hopkins Burr was Ebenezer's youngest child. Located at 250 South Park Drive, the western half of the house was built in 1737 by Ebenezer Hopkins. The 78-acre farm property was purchased in 1866 by early photographic paper manufacturer and chemist David Morgan, who pioneered a high-quality albumen process. Today, the building houses the Camden County Cultural and Heritage Commission administered by the Camden County Library System. An undated, earlier view of the Hopkins-Burr house is shown below. (Both, courtesy of Historical Society of Haddonfield.)

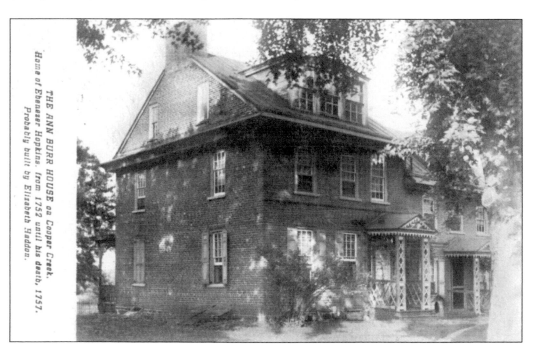

THE ANN BURR HOUSE on Cooper Creek. Home of Ebenezer Hopkins, from 1752 until his death, 1757. Probably built by Elizabeth Haddon.

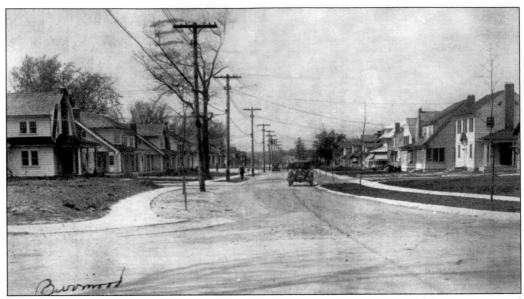

Burrwood Avenue in the Bluebird community is shown about 1925. Burrwood Avenue is named for Ann Hopkins Burr, the 19th-century owner of the property on which the community was built. (Courtesy of Collingswood Public Library.)

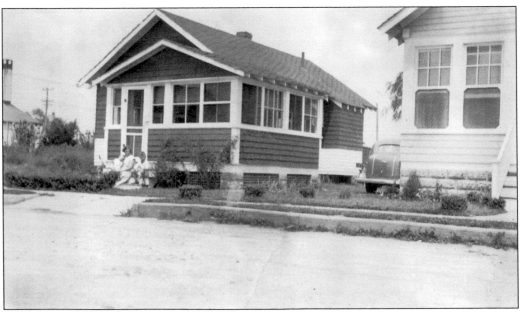

This is a c. 1930 view of a bungalow on New Jersey Avenue that was once occupied by Alfred H. and Marjorie Cameron Turner before they moved into their newly constructed house on 202 Burrwood Avenue. (Courtesy of the Turner-Parker family.)

The Arthur Berrigan family residence at 201 Harding Avenue in the Bluebird community of Haddon Township is shown in about 1929. (Courtesy of Jack Berrigan and Lorraine Leary.)

In this c. 1944 photograph is Otto and Helen Wisner's house at 9 Lockland Avenue. The Wisner home was one of the first houses built on the street. (Courtesy of Jean Alley.)

Here is Cuthbert Road (formerly Mill Road), between Haddon Avenue and the White Horse Pike, as it appeared 1899. The road is named for Joseph Ogden Cuthbert, whose farm was at the Haddon Avenue end of the road. (Courtesy of Historical Society of Haddonfield.)

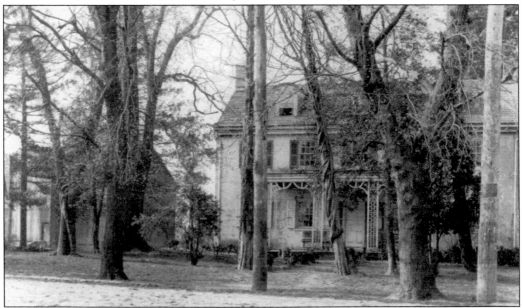

The Cuthbert homestead, owned by Joseph Ogden Cuthbert and Elizabeth Coles Cuthbert, was purchased in 1850 from the estate of Daniel Conard. The house stood on the southeast corner of Haddon Avenue and Cuthbert Road. A railroad stop located nearby was named the Cuthbert Station. A drugstore now stands on the site. (Courtesy of William G. Rohrer Memorial Library, Camden County Library System.)

To Joseph O Cuthbert

Your Tax for the year 1858, in the Township of Newton, has been assessed as follows:

(Rates of Assessment, 36 cents on the $100 Valuation.)

REAL ESTATE			Value of Personal Estate	Total Taxable Estate.	Poll Tax.	Dog Tax.	School Tax		Total Tax.
Acres of Land	Houses and Lots.	Value of Real Estate.							
111		$9990	$1520	$8190	50	150	$8.19		$39.67

Returnable on the 20th of October Appeal on the 13th of September, at the Hall in Haddonfield.

I will attend at John Dobbins' Office, in Centreville, on the 15th, at the School House in the Fifth District on the 16th, at Champion's School House on the 18th, and at the Town Hall in Haddonfield, on the 19th day of October next, for the receipt of Taxes.

RICHARD SNOWDON, Collector.

Received payment of the above bill in full

Collector

October 1858

Above is an 1858 property tax bill for Joseph Ogden Cuthbert's 111-acre property. Notice it was still called Newton Township. Henry Cuthbert ran the farm after his father, Joseph, retired in the 1860s. The Cuthberts raised typical farm produce—potatoes, apples, hay, and corn—which they sometimes used to barter for services from other local craftsmen, millers, and merchants. The Cuthbert barn is seen below as it appeared about 1912. (Above, courtesy of William C. McKenna; below, courtesy of Paul W. Schopp Collections.)

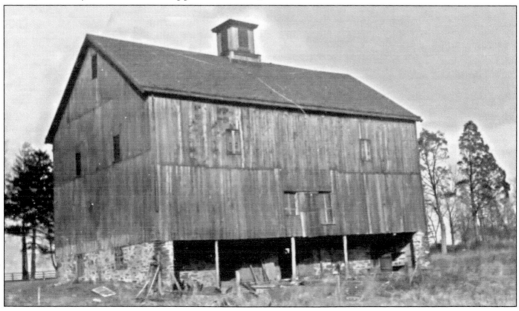

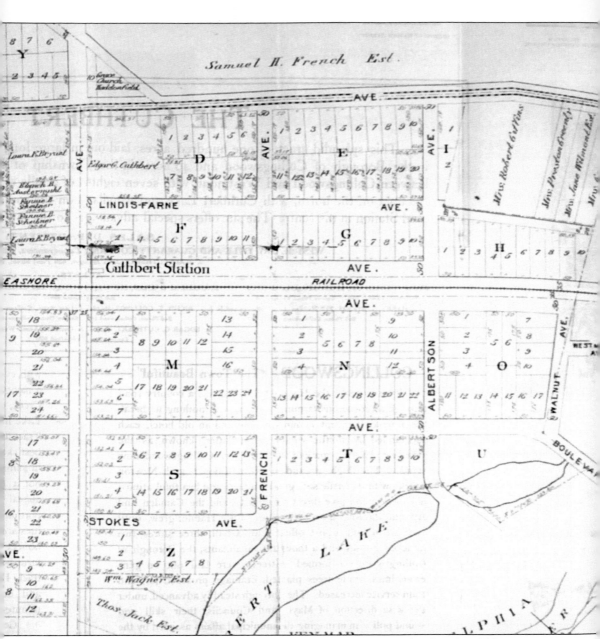

After Joseph Ogden Cuthbert's death, family members decided to develop the old farm, as seen in this Cuthbert tract map from about 1912. Many present streets were laid out, and names remain. Some take their name from associated families. Lindisfarne takes its name from the historical figure Saint Cuthbert of Lindisfarne in Scotland. (Courtesy of William C. McKenna.)

In 1921, Anthony and Rosa DePalma purchased the property at 10 Haddon Avenue, shown at right in 1922. Fanny DePalma-Orihel and husband, Steve, purchased Fanny's parents' house in 1943, where the Orihel family lived until 1968. (Courtesy of the Orihel family.)

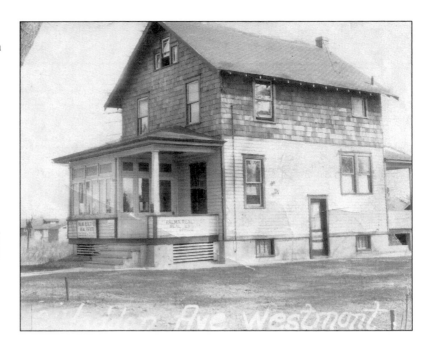

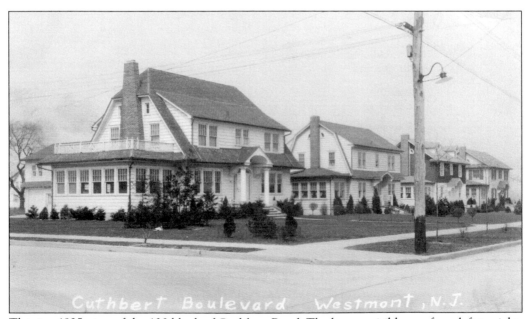

This is a 1925 view of the 100 block of Cuthbert Road. The houses visible are, from left to right, 101, 103, 105, and 107. The Nothnagel family lived at 103 Cuthbert Road from 1932 until about 1963. (Courtesy of Louise Nothnagel Williams.)

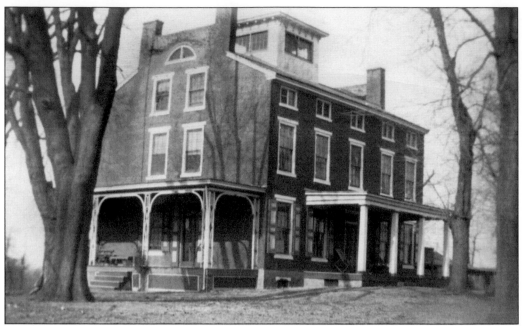

The history of this house can be traced back to at least 1853 when Samuel Vaughan Merrick, first president of the Pennsylvania Railroad and a founder of the Franklin Institute in Philadelphia, purchased the property. From 1864 through 1880, John Mickle Whitall, a sea captain turned successful glass manufacturer, owned the 120-acre estate. The Merrick and Whitall families used the Haddon Township property as their summer residence. In the 20th century, the property was purchased by Joseph Bishop Van Sciver, a prominent furniture manufacturer. His sister Anne, her husband, Ambrose Jarvis, and their son Clarence operated the farm located off Cuthbert Road. The house, seen above about 1940 and below about 1960, was destroyed by fire in 1967. (Above, courtesy of Walt Boland; below, courtesy of Herta Scheidhauer.)

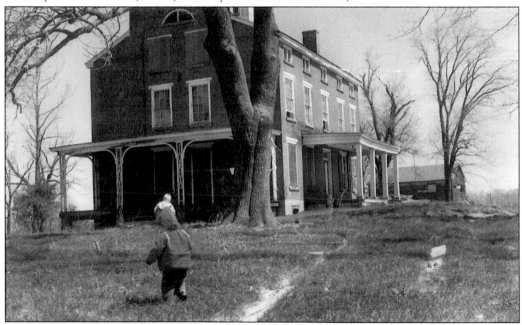

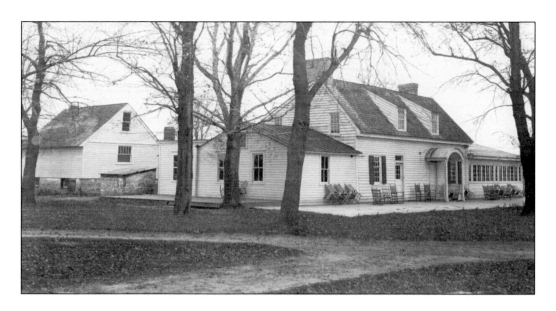

Seen above, the 18th-century farm known as the Hinchman homestead was located on the north side of Kings Highway West from about Avondale Avenue to Hopkins Avenue in Haddon Township. In the early 20th century, the house and land were leased to the Haddon Country Club, a golf and tennis club, which operated on the site until 1921, when Tavistock Country Club was created. In the 1942 photograph below is 344 Avondale Avenue, one of many houses built on the former Haddon Country Club property. This section of Haddon Township is known as Haddonleigh. (Above, courtesy of Historical Society of Haddonfield; below, courtesy of Jim Harvey.)

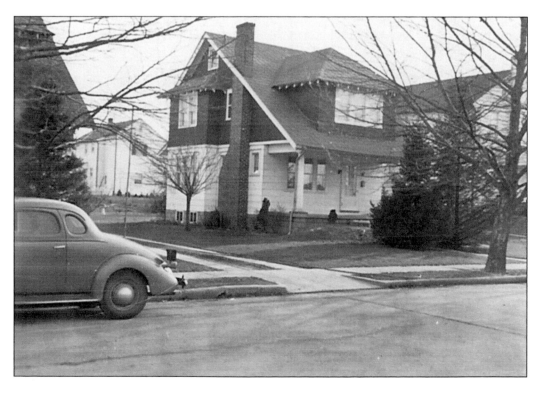

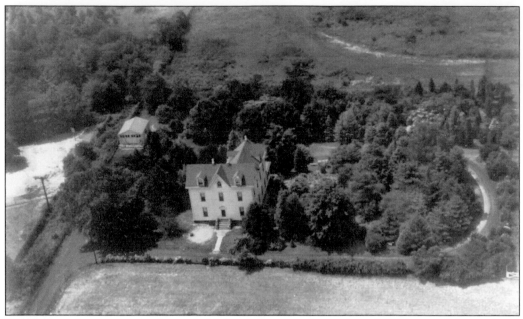

The Webster house, seen in this early-20th–century aerial view, (now 205 Memorial Avenue) was surrounded by farmland. In the 1800s, this farm contained 30 acres of land and at least two barns. In the early 1800s, the Webster family operated the Newton Gristmill, later called Cuthbert's Mill. (Courtesy of Robert and Bernadette Mehmet.)

The Haddon Hills Estates were single-family, colonial-style homes built in the early 1950s and stretched from Crystal Lake Avenue down to Crestwood Avenue. Author William B. Brahms is shown in front of his house on the 300 block of Briarwood Avenue, a few years after his family moved there in the late 1960s from the Haddon Hills Apartments. (Courtesy of William B. Brahms.)

Haddon Hills Apartments were built in the 1940s on part of the old Stoy estate. Bound by Park and Crystal Lake Avenues and bisected by Pyle Avenue, the complex features single-floor, two or three-bedroom apartments, as well as two-story duplexes. Early residents recall that the apartments provided a close-knit–community atmosphere, where many young families began their association with Haddon Township. As their families grew, they often moved on to the new nearby developments, such as Haddon Hills Estates or Twentieth Century Homes (a development of ranch-style houses at Memorial Avenue.) Above is a neighborhood party in 1963, and below is a three-generation family gathering about 1965. (Both, courtesy of William B. Brahms.)

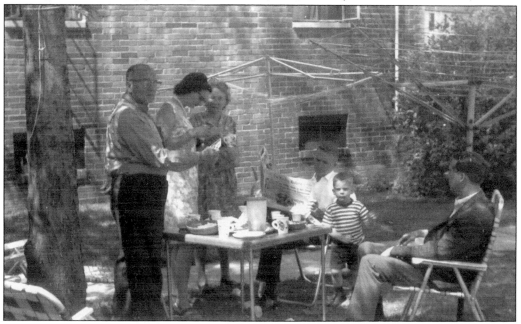

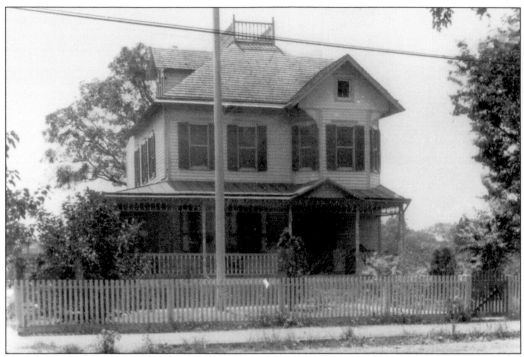

This is the Edward Martin house at Haddon and West Walnut Avenues as it appeared in 1907. A committee to establish the Westmont Fire Company met here on June 7, 1902. When a modern firehouse was built in 1952, the Martin house was demolished so that the firehouse could be built on the site. (Courtesy of William G. Rohrer Memorial Library, Camden County Library System.)

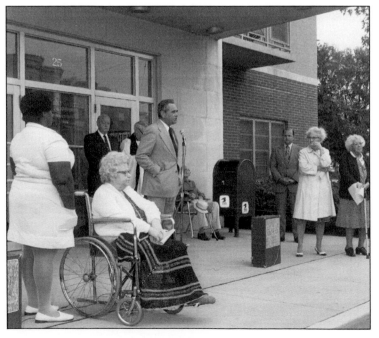

Longtime Haddon Township mayor William G. Rohrer initiated a new concept in rent-subsidized affordable senior housing when Rohrer Towers at 25 Wynnewood Avenue was dedicated in 1968. Commissioner Richard J. Hardenbergh, an insurance agency owner, is at the microphone. With construction of Rohrer Towers II (built in 1981) and Coles Landing, housing for hundreds of senior residents is now available in Haddon Township. (Courtesy of Haddon Township.)

Agnes and Daniel Linderman moved into their 28 East Oakland Avenue home, seen above, in 1921, where they raised four children: Norman, Mildred, Doris, and Mary. The property was one of the earliest houses built on the 92-acre Bettlewood tract named for William Bettle Jr., landowner and farmer. The house at 2 East Clinton Avenue, built sometime around the 1850s and owned by William Bettle Jr., is in the photograph below. It remained in the Bettle family until the early 20th century. (Above, courtesy of Doris Linderman Palmer; below, courtesy of the Hearey family.)

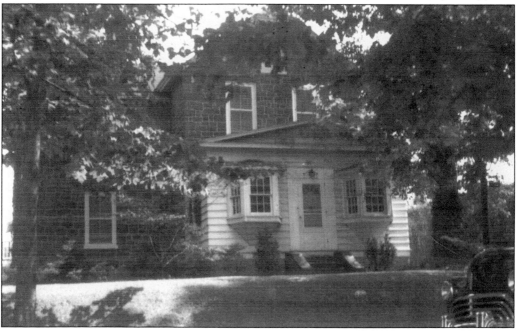

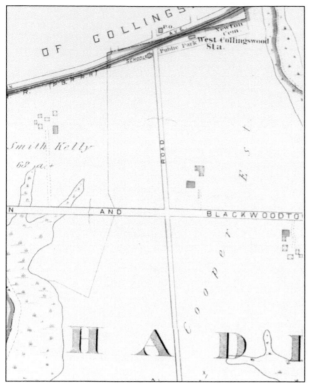

Two views from the same 1907 map show the westernmost parts of Haddon Township. The West Collingswood Extension, illustrated at left, was ostensibly the Samuel Cooper Estate dotted with only a handful of buildings. The land here was the location of the first European settlement in the area. Quakers settled here in the early 1680s and became the genesis for settlement in present-day Haddonfield and surrounding townships. The West Collingswood Heights, below, was also in the hands of a few estates, bisected only by Nicholson Road and the Black Horse Pike. These main roads remain major thoroughfares, but dozens of streets have replaced the acres of farmland that were here 100 years ago. (Both, courtesy of William B. Brahms.)

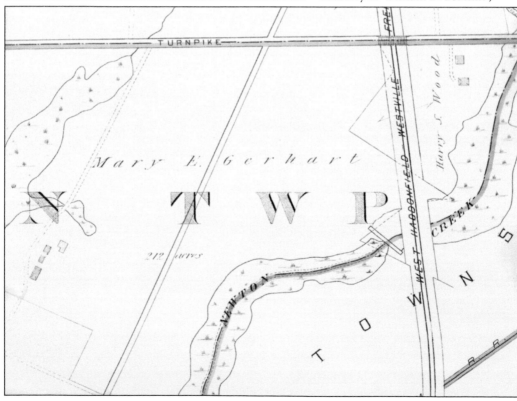

Two

EDUCATION

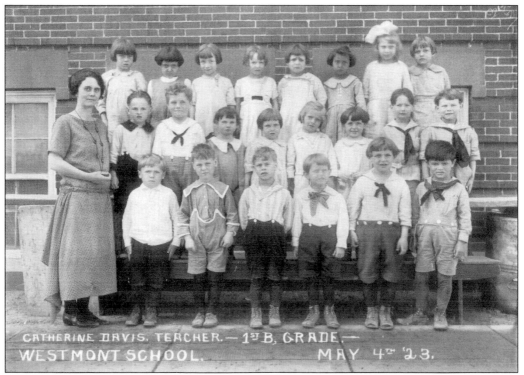

Pictured here are Catherine Davis and her first-grade class at the Westmont School in 1923. (Courtesy of William G. Rohrer Memorial Library, Camden County Library System.)

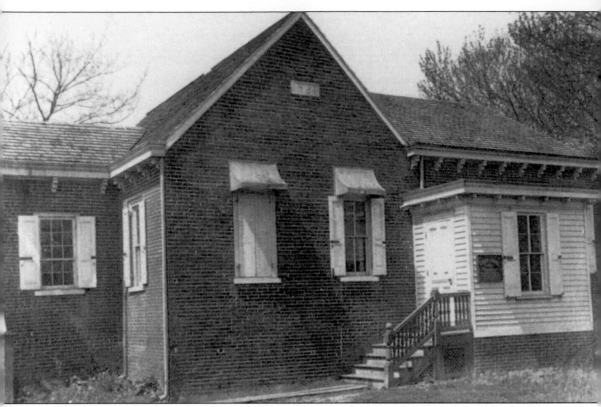

The Champion School, seen here in 1909, was built as the Newton Union School by the Newton Union School Society in 1821. It was later renamed for local landowner Samuel Champion, who played an important role in resolving a title issue that concerned the land on which the school was built. When the New Jersey Public School Act was passed in 1838, the Champion School was named the first free public school in old Gloucester County (now Camden County). It remained a public school until 1906, when the Thomas Sharp School was built. The Champion School building was later used at various times as a meeting place for church services, clubs, boy scouts, and other organizations. The school stands in the West Collingswood Extension on Collings and Lynne Avenues. It has been preserved through the dedicated work of resident volunteers. (Courtesy of Camden County Historical Society.)

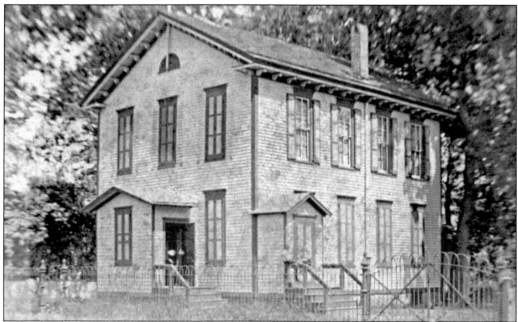

The Rowandtown (later known as Westmont) schoolhouse was completed in 1872. The small annex seen at the rear of the building in the photograph below was built by Esterbrook Reeve in 1901. By about 1907, the schoolhouse and annex were separately moved to make room for the new Westmont (also known as Haddon Avenue) School. The old schoolhouse became the First Methodist Mission at 22–24 Center Street. The annex continued as classrooms for kindergarten and first-grade children. It later became the police headquarters, then the Haddon Township Library, and now it serves as a municipal annex building. (Above, courtesy of William C. McKenna; below, courtesy of William G. Rohrer Memorial Library, Camden County Library System.)

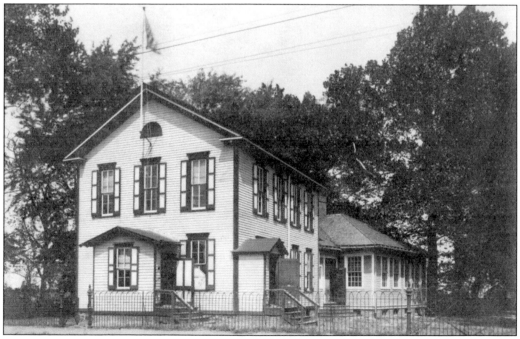

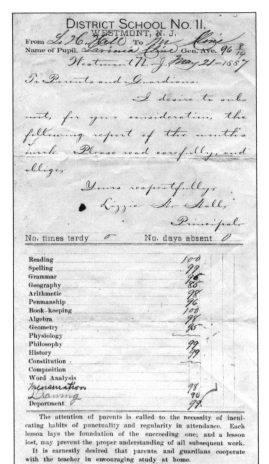

WESTMONT, N. J.

From *L. H. Hall* To *Mr. Cline*

Name of Pupil. *Lavinia Cline* Gen. Ave. 96 8/14

Westmont N. J. May 21—1887

To Parents and Guardians:

I desire to submit, for your consideration, the following report of the month's work. Please read carefully, and oblige.

Yours respectfully,

Lizzie H. Hall,

Principal.

No. times tardy 0 No. days absent 0

Reading	100
Spelling	99
Grammar	96
Geography	85
Arithmetic	98
Penmanship	96
Book-keeping	100
Algebra	98
Geometry	95
Physiology	
Philosophy	99
History	99
Constitution	
Composition	
Word Analysis	
Examination	98
Drawing	90
Deportment	99

The attention of parents is called to the necessity of inculcating habits of punctuality and regularity in attendance. Each lesson lays the foundation of the succeeding one; and a lesson lost, may prevent the proper understanding of all subsequent work.

It is earnestly desired that parents and guardians cooperate with the teacher in encouraging study at home.

This is a report card dated 1887 for Lavinia Cline from Lizzy H. Hall, principal of the Westmont (formerly Rowandtown) School. Lavinia, born about 1870, was the daughter of Silas Cline and Mary V. Doyle Cline of Haddon Township. She married William Hinchman of Haddonfield in 1893. (Courtesy of Historical Society of Haddonfield.)

This 1894 class photograph shows the Westmont School located on Haddon Avenue on the property of the current municipal building. In the late 1880s, the school name was changed from the Rowandtown School to the Westmont School to reflect the town's name change. (Courtesy of William G. Rohrer Memorial Library, Camden County Library System.)

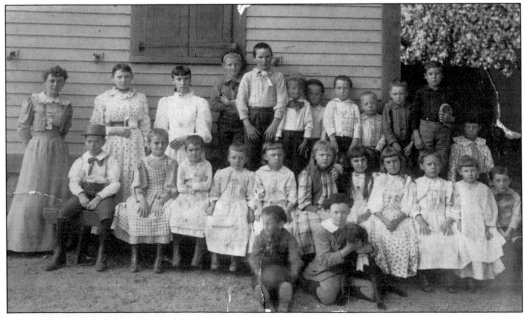

1899

Program and Time Table.

Miss Edna's	Miss Laura's
9.–9.10 Opening Exercises	9.–9.10 Opening Exercises
9.10–9.20 Bill Class	9.10–9.25 Algebra *Page 23*
9.20–9.30 Time Class	9.25–9.35 "C" Grammar *Lesson 10*
9.30–9.45 Primer Class	9.35–9.50 "B" Grammar *Lesson 45*
9.45–10.00 Language (2.)	9.50–10.00 "A" Grammar *History or 116*
10.00–10.15 Table Class	10.00–10.15 "B" Reading *Page 40*
10.15–10.30 To View Work	10.15–10.30 "C" Reading *Page 170*
Recess	Recess
10.45–11.10 "B" Arithmetic *Page 122*	10.45–11 Physiology or Physics *Chapter 13 –*
11.10–11.30 "C" Arithmetic *Page 54*	11–11.15 First Reader *Page 9*
11.30–12 "A" Arithmetic *Page 195*	11.15–11.30 Second Reader *Page 9*
	11.30–11.45 "B" Physiology or History *Page 25–30*
	11.45–12 "C" Physiology *Page 15–21*
Noon	Noon
2.05–2.20 "B" Geography *Page 14*	2.–2.05 Roll Call.
2.20–2.30 "C" Geography *Page 241*	2.05–2.20 Constitution *Art. I*
2.30–2.45 "A" Geography *Page 79*	2.20–2.30 Writing
Recess	2.30–2.45 First Reader *9.*
3.–3.10 Primer Class	Recess
3.10–3.30 Writing Small Classes	3.–3.10 "B" Spelling *Lesson 61 – Page 57*
3.30–4.00 "B" & "C" Writing	3.10–3.20 "A" Spelling or Etymology *Page 69 Book 92*
Friday – Drawing	3.20–3.30 "C" Spelling *Page 15*
	3.30–4.00 "A" Reading *Page 41 to 47*
	Friday – Drawing

This daily plan for classes at the Westmont schoolhouse is dated 1899. At the time, the school was divided into educational sections depending upon the student's age. (Courtesy of William G. Rohrer Memorial Library, Camden County Library System.)

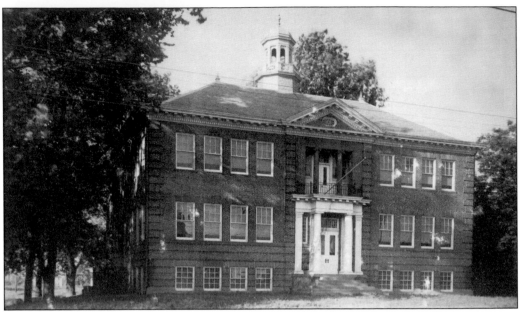

The modern brick Westmont School seen above was constructed in 1908 at the intersection of Haddon and Reeve Avenues. The Westmont School was built by D.W. Stoy and designed by W.T. Towner for the total cost of about $25,000. The school was formally dedicated in April 1909. The building held eight classrooms and was the main school in Haddon Township until the late 1920s, when other elementary schools were built. After 1930, junior high school students attended the Thomas A. Edison School (now an elementary school). The Westmont School was torn down on July 9, 1961, to make room for the Haddon Township municipal building. The class photograph below from the Westmont School is dated around 1915 to 1920. (Above, courtesy of Collingswood Public Library; below, courtesy of William G. Rohrer Memorial Library, Camden County Library System.)

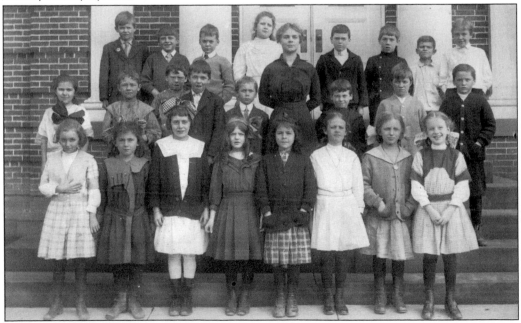

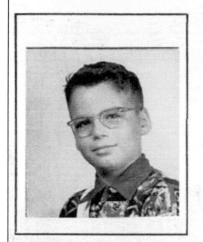

MEMBERSHIP CARD
SCHOOL SAFETY PATROL

This Certifies That

Michael Murray

IS A MEMBER OF THE

Haddon Ave

SCHOOL SAFETY PATROL

Miss Hawk

PRINCIPAL

53-54

SCHOOL YEAR

This safety patrol identification card was issued to Michael Murray, a Haddon Avenue School student and captain of the safety patrol. The captain of the safety patrol assigned all members to their corner posts and, on bicycle, made daily rounds to all corner posts. A highlight of being in the safety patrol was the annual bus trip to Washington, DC, to participate in a national safety patrol march. (Courtesy of R. Michael Murray, Esq.)

About 1930, Lindy showed up at the Westmont School during recess one day and never left. Named for a 1927 Lindbergh medal found around his neck, he shared recess snacks and was soon invited into the classroom, sleeping under the teacher's desk and "repeating third grade many times," according to teacher Mabel Snyder. The well-mannered dog was also adopted as the police mascot. (Courtesy of Haddon Township Police Department Collection.)

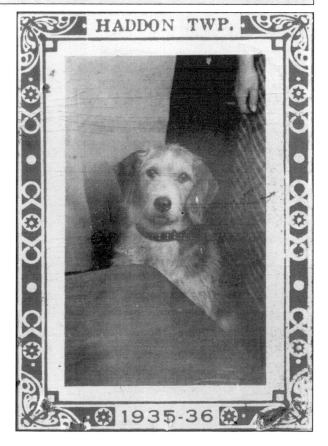

HADDON TWP.

1935-36

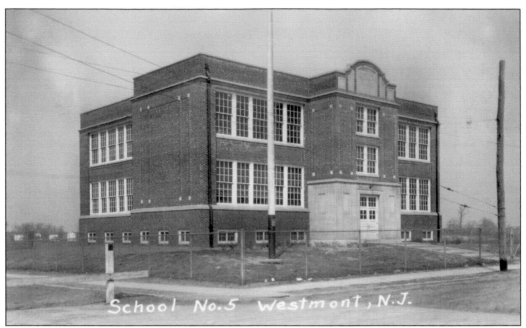

School No.5 Westmont, N.J.

Strawbridge School was built in 1925. The photograph above was taken during construction or shortly after. At the time, the school was designated only as School No. 5. In about 1928, it took on the more familiar name, Strawbridge Avenue School. The school is located at 307 Strawbridge Avenue. The photograph below shows an addition during construction in 1950. (Above, courtesy of William G. Rohrer Memorial Library, Camden County Library System; below, courtesy of Strawbridge School PTA.)

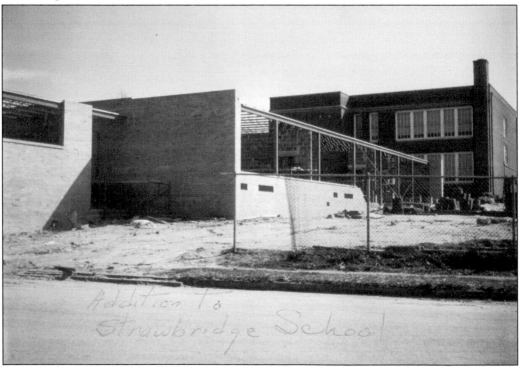

Addition to Strawbridge School

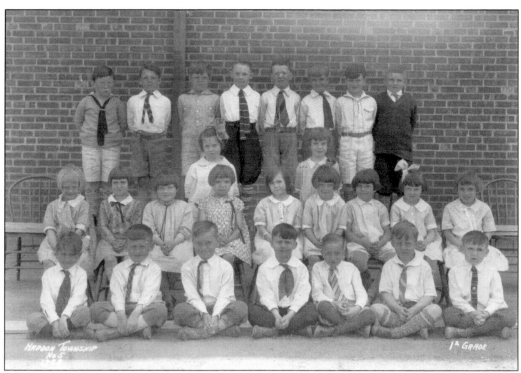

Above is a 1928 first-grade class photograph from Strawbridge School, and below is a 1950s fourth-grade class photograph showing the interior of a typical Strawbridge classroom. (Above, courtesy of William G. Rohrer Memorial Library, Camden County Library System; below, courtesy of Jean Alley.)

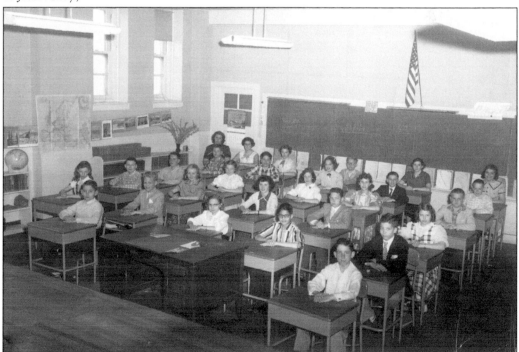

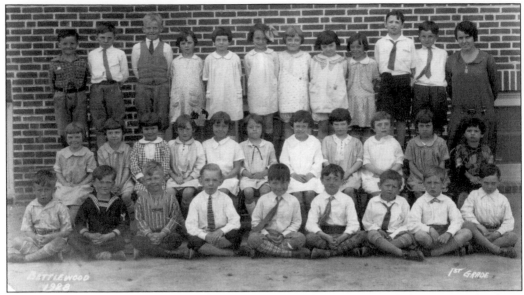

The Bettlewood School was constructed in 1927. The school was originally known as School No. 6, but soon after, it took the name Bettlewood, a name it shared with the neighboring community. The Bettlewood neighborhood is named for William Bettle Jr. who, in 1865, owned 92 acres in the area. Ina L. Ashton was the school's first principal. In January 1960, the Bettlewood School was formally renamed the Clyde S. Jennings School after a local school official. Jennings School is located at 100 East Cedar Avenue. The above 1928 photograph shows first-grade students; below, the combined seventh- and eighth-grade students of 1928 are pictured. (Both, courtesy of Doris Linderman Palmer.)

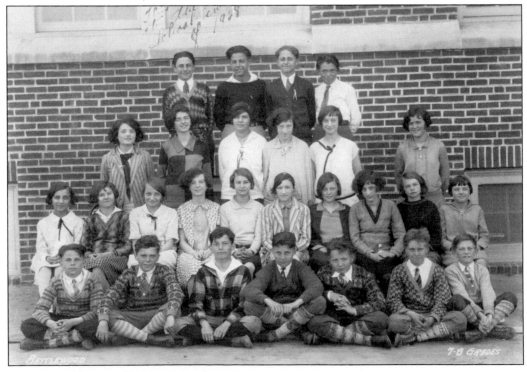

The James Stoy School was constructed in 1928 under board of education president J.R.Y. Blakely. It was designed by architect Charles R. Peddle and built by the Camden Construction Company. The building's four classrooms reflected that the school was originally intended to educate only grades one through four. In 1956, a main central portion of the building that features an all-purpose room and central corridor of classrooms was added. James Stoy was an early Haddon Township landowner who provided the land for a school on Haddon Avenue in about 1840. The James Stoy School is located at 206 Briarwood Avenue. The class photograph below shows a fourth-grade class in 1934. (Right, courtesy of William B. Brahms; below, courtesy of William G. Rohrer Memorial Library, Camden County Library System.)

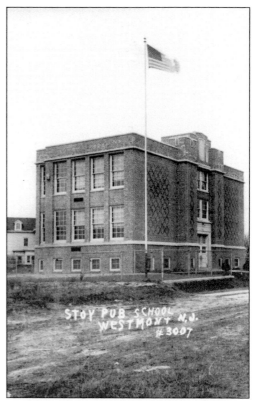

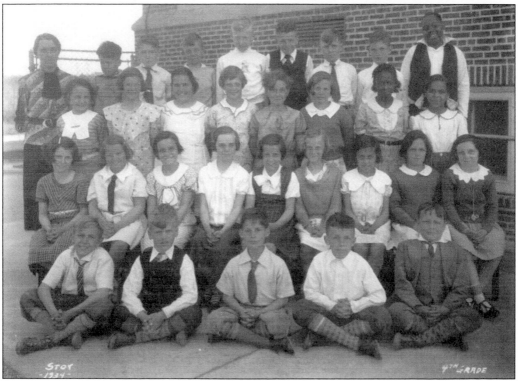

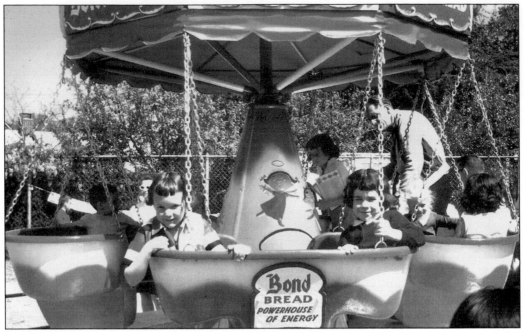

Haddon Township children Anita Geismar, left, and Bernadette Gavin enjoy one of the amusement rides at the annual Stoy School fair in 1962. (Courtesy of Anita C. Geismar, Edward V. Geismar Collection.)

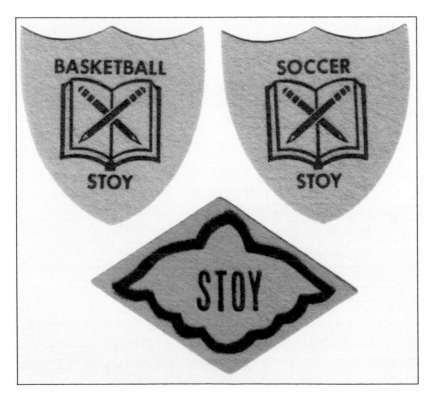

Pictured are Stoy School patches from the 1960s and 1970s. (Courtesy of William B. Brahms.)

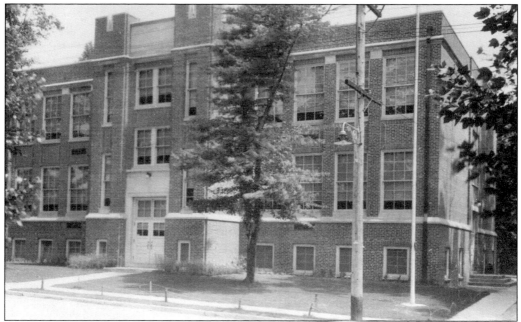

The Thomas A. Edison School, constructed in 1930 as a junior high school, was known originally as School No. 3. The name was changed in honor of the famous inventor who has no connection to this specific area but died shortly after the school was built. As the township's population increased, the need for a dedicated junior high school resulted in construction of the Thomas A. Edison Junior High School at 205 Melrose Avenue. The photograph below shows the eighth-grade class of 1938 in front of the school building. Edison served as a junior high school until the more modern and centrally located Haddon Township Junior High School was built in 1951. After 1951, Edison School became an elementary school. (Both, courtesy of William G. Rohrer Memorial Library, Camden County Library System.)

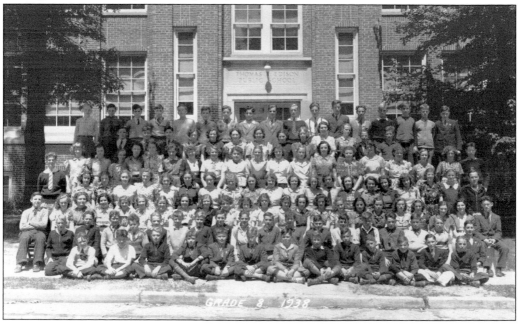

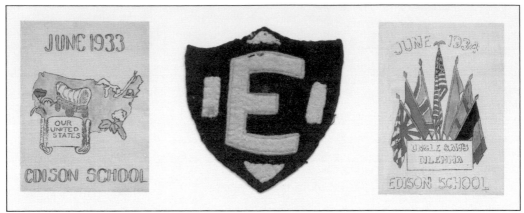

Seen here is a school patch with paper memorabilia from the Thomas A. Edison School from the 1930s and 1940s. (Patch, courtesy of Carl Rugart; paper memorabilia, William G. Rohrer Memorial Library, Camden County Library System.)

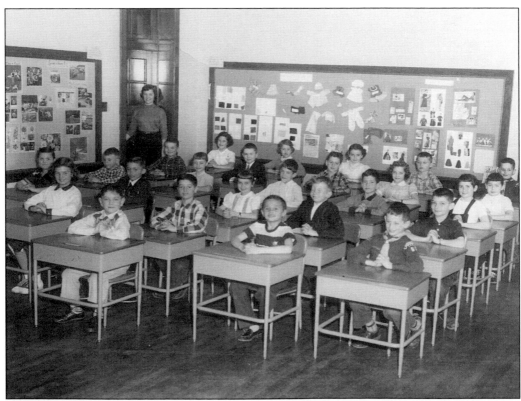

Pictured here is a third-grade classroom at Thomas A. Edison School in 1955. The boy in the Cub Scout uniform in the front to the right is Steven Spielberg. Spielberg, who lived on Crystal Terrace in the Haddonleigh section, took the bus to Edison. Spielberg makes references to this area, including mentioning Haddonfield in the film *A.I. Artificial Intelligence* and referencing Thomas Alva Edison School in *Saving Private Ryan*. (Courtesy of Haddon Township Historical Society Collection.)

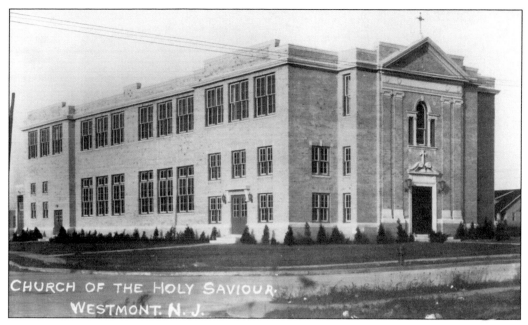

CHURCH OF THE HOLY SAVIOUR.
WESTMONT. N. J.

The Holy Saviour parish was established in 1928. Sunday Mass was celebrated at the Westmont Theatre until the new combination church-and-school building, pictured above in the 1930s, was completed by Christmas Eve in 1929. Most of the parish complex was built during the pastorate (1937–1962) of Msgr. Francis J. Garvey. The school was initially staffed by the Sisters of Charity of Halifax, Nova Scotia. The sisters originally resided in a rented house at 88 Elgin Avenue before moving to 300 Cooper Street in 1931 until the convent was completed in 1948. A new school building with eight classrooms and a multipurpose room was dedicated in 1958. Below is a photograph of a class in the 1950s. (Both, courtesy of Sandra White-Grear.)

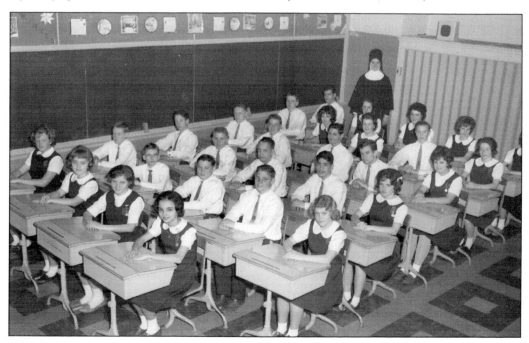

Haddon Township Junior High School building was completed in 1951. The new junior high school included classes for grades seven through nine, after which, students would attend high school outside of Haddon Township. The completed junior high school was a single-story, U-shaped building, which is now the front portion of the current Haddon Township High School. (Courtesy of William B. Brahms.)

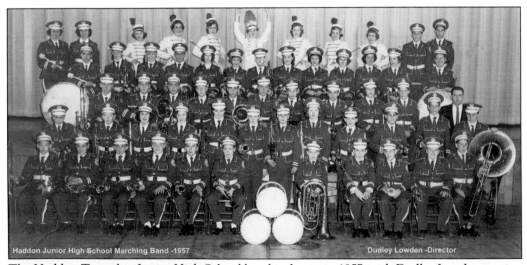

Haddon Junior High School Marching Band -1957 Dudley Lowden -Director

The Haddon Township Junior High School band is shown in 1957, with Dudley Lowden serving as band director. (Courtesy of R. Michael Murray, Esq.)

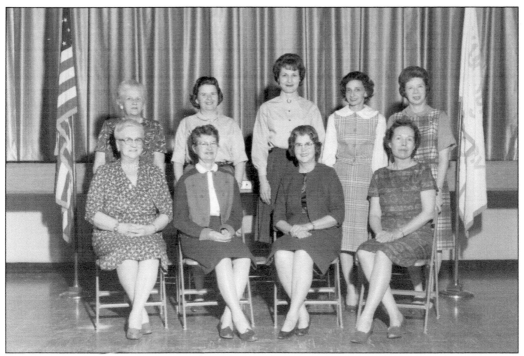

Van Sciver School was constructed in 1957 under superintendent of schools John W. Brown and school board president Franklin P. Jackson. J.B. Van Sciver Furniture Company was a major furniture manufacturer in Camden, New Jersey, from the 1880s through to the 1970s. The Van Sciver family owned a 120-acre farm in Haddon Township from 1914 through 1961. As the farm's acreage dwindled and suburban neighborhoods grew, nine acres were portioned off for the development of the new Van Sciver School. Pictured above are the 1963–1964 teachers, and below is an interesting old playground view that many remember from the 1970s and 1980s. (Both, courtesy of Van Sciver School.)

Both high schools in Haddon Township were built in the 1960s. Pictured above is Haddon Township High School, designed by architect George Von Uffel, which joined the original junior high school building with an added two-story wing of classrooms, auditorium, cafeteria, and gymnasium. The school was formally dedicated on November 4, 1962. Below is Paul VI High School, a private Catholic high school that opened in 1966 in the Diocese of Camden. Designed by architect Armond Nasuti, the school building has two wings emanating from a central office area, resembling the outstretched wings of an eagle. The eagle later became the school mascot. The school opened with 613 students under principal Reverend Joseph Von Hartleben, with a faculty of 10 priests, 18 sisters of the Religious Teachers Filippini, and 10 lay teachers. (Above, courtesy of Mark Zeigler; below, courtesy of Paul VI High School.)

Three

TRANSPORTATION

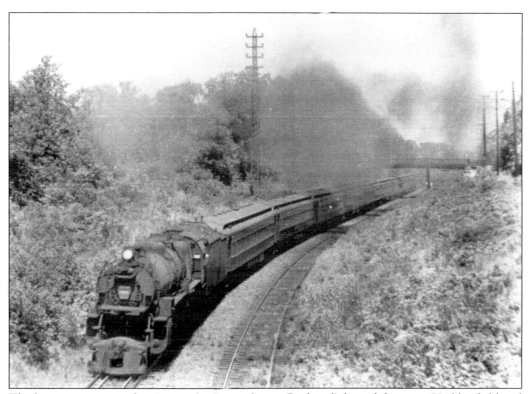

The last steam-powered trains on the Pennsylvania Railroad's branch between Haddonfield and Philadelphia via the Delair Bridge ran during the summer of 1957. This view of a southbound Atlantic City racetrack special was taken from the Haddon Avenue Bridge the previous summer. The Maple Avenue Bridge is in the background. (Courtesy of Cliff Brunker, H. Gerald MacDonald collection.)

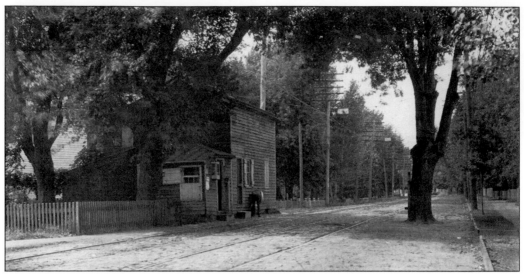

The tollgate seen above was near the southwestern corner of Haddon and Crystal Lake Avenues, approximately where the present Sentry Office Plaza stands. The Haddonfield and Camden Turnpike Company, incorporated in 1839, operated Haddon Avenue as a toll road. In 1868, the toll was 1.5¢ per mile for a horse and vehicle. The Stoy family was employed to maintain the highway at Rowandtown, which was the pre-1886 name for Westmont. The stock certificate shown below is from the Haddonfield and Camden Turnpike Company. (Above, courtesy of Anne and Boyd Hitchner; below, courtesy of William B. Brahms.)

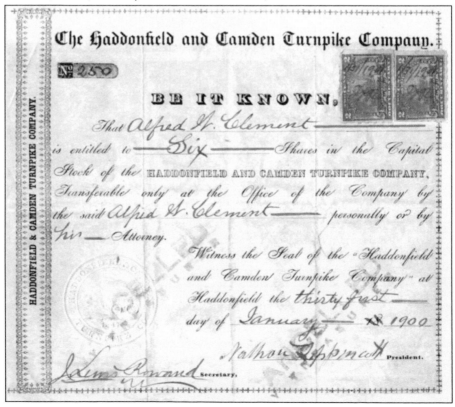

The White Horse Pike was one of several once privately owned turnpikes. Road maintenance was the main reason for the toll roads. As technology for better road surfaces improved and automobile traffic increased, the pikes disappeared. In 1922, the concrete White Horse Pike was formally dedicated. The ribbon is from 1922, when the White Horse Pike was the largest continuous concrete road in America. (Courtesy of William B. Brahms.)

COMMITTEE

WHITE HORSE
PIKE
OPENING
CELEBRATION

NOV. 4,
1922

Esterbrook Reeve, son of Edward Reeve and Mary Baker Reeve, drives his horse and buggy on Cuthbert Road in the late 1890s. Reeve served in many capacities in Haddon Township, including as a home builder, volunteer fireman, and Democratic committeeman. In 1902, he built Reeve Avenue, which ran through the Reeve property. (Courtesy of William G. Rohrer Memorial Library, Camden County Library System.)

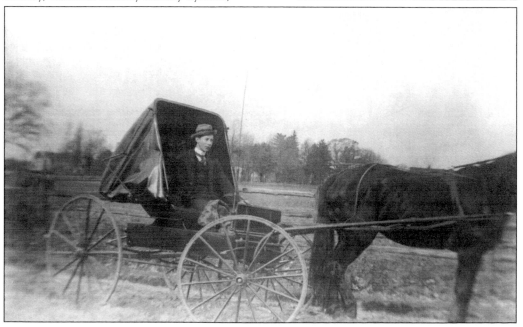

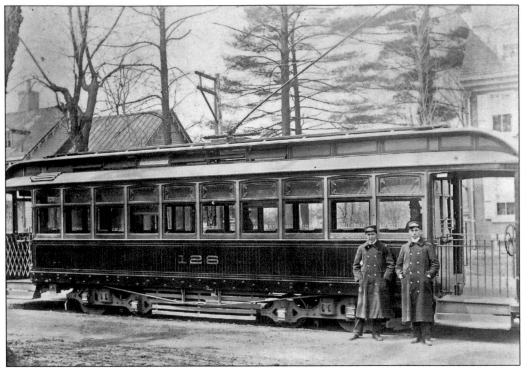

Public Service trolleys established in 1895 on Haddon Avenue were replaced in 1932 by less-expensive-to-operate buses. The trolley fare was a nickel, and open cars were used in the summer. (Courtesy of Collingswood Public Library.)

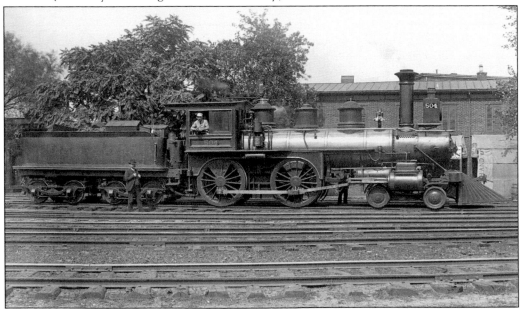

This early photograph of engine No. 504 of the Camden and Atlantic Railroad, a 4-4-0 locomotive, was taken on August 31, 1887. The locomotive is a stark contrast to those built by the Budd Company for the PATCO Hi-Speed Line trains that still run on the same path through Westmont. (Courtesy of William B. Brahms.)

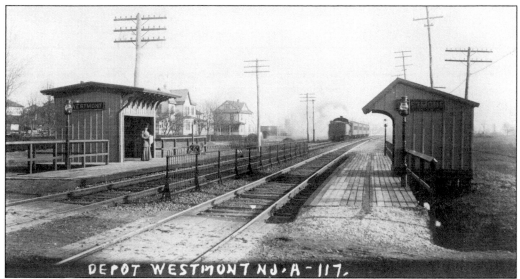

DEPOT WESTMONT NJ·A-117.

The Camden and Atlantic Railroad began service between Coopers Point, Camden, and Haddonfield through old Newton Township (later Haddon Township) in September 1853. After opening to Berlin in April 1854, service began to Atlantic City in June 1854. The residential, agricultural, and industrial growth of line-side communities, such as Rowandtown, and the birth of Atlantic City was the direct result of the 58.7-mile-long railroad. In 1875, Haddon Township residents could travel to Camden for 25¢, which included the 5¢ Philadelphia ferry transfer. After leaving Redman's Lane station in Haddonfield, Camden local trains stopped at Rowandtown (Westmont in the late 1880s, as seen in the above photograph). Below is a 1941 view of the Pennsylvania-Reading Seashore Lines' Crystal Lake Avenue railroad crossing and passenger shelter, looking south toward Stoy Avenue. (Above, Courtesy of Collingswood Public Library; below, courtesy of Cliff Brunker, photograph by Don Wentzel.)

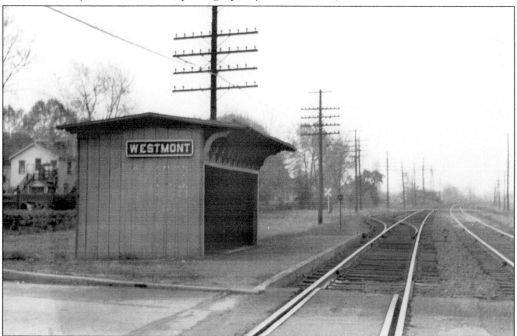

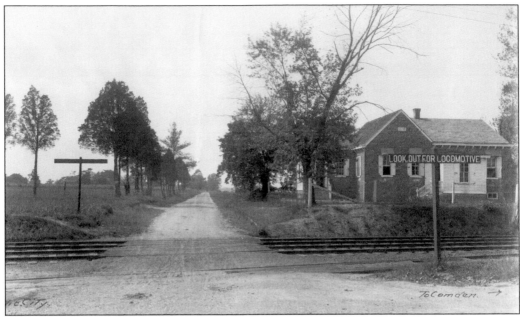

A disagreement between Camden and Atlantic board directors led to the opening of a competing railroad named the Philadelphia & Atlantic City Railroad. This narrow-gauge (42-inch) 54.6-mile line between south Camden and Atlantic City was hastily built in just 96 days. Trains began running July 21, 1877, in time for most of the summer seashore resort season. Poor equipment and track resulted in little business, and the line failed. After acquiring it, the Philadelphia & Reading Railroad converted it to standard gauge and otherwise greatly improved it. The above photograph shows an unpaved Collings Avenue, with the Champion School on the right. Below offers a view of the railroad station built just off Collings Avenue in 1890. (Both, courtesy of Jim Kranefeld.)

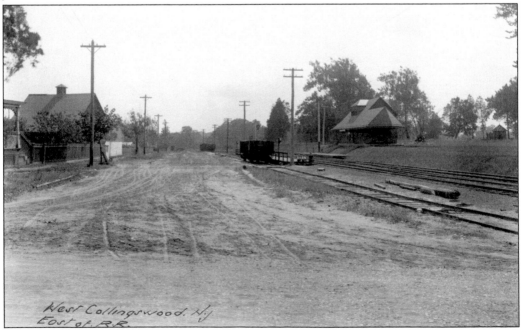

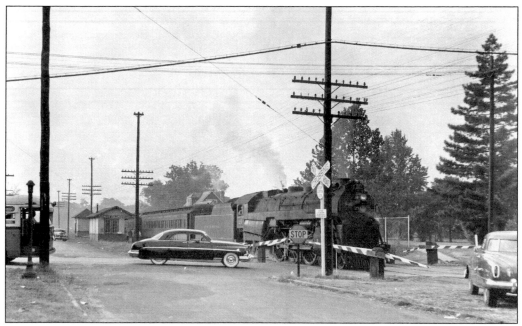

The Pennsylvania-Reading Seashore Lines train No. 610 boards passengers at the West Collingswood station at Collings Avenue on September 3, 1953. (Photograph by and courtesy of Robert L. Long, West Jersey Chapter National Railway Historical Society.)

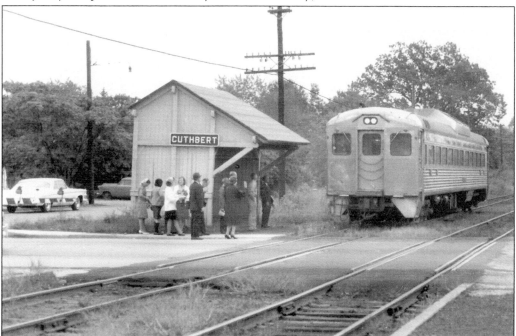

The Pennsylvania-Reading Seashore Lines' Cuthbert Station was a flag stop without an agent or ticket seller and was served only by local trains. Trolley and, later, highway competition resulted in a gradual decline. By September 1964, when this photograph was taken, there were only three inbound morning and one late-afternoon outbound trains stopping on weekdays, with none stopping on weekends or holidays. (Courtesy of Cliff Brunker; photograph by William J. Coxey.)

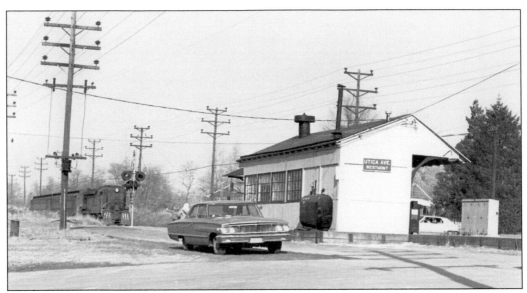

Pictured above is the Utica Avenue Station of the Pennsylvania Railroad (Penn Central beginning February 1968), which opened on November 14, 1966. It replaced the Pennsylvania-Reading Seashore Lines' Haddonfield stations that were abandoned to make way for PATCO, the new transit line. When this photograph was taken on January 22, 1967, there were six weekday Philadelphia–Atlantic City round-trips (three on weekends) and one to Ocean City, Wildwood, and Cape May (none on weekends). The ticket office closed in January 1969, and the station was abandoned on October 1, 1969, when the Hi-Speed Line began providing all train service between Lindenwold and Philadelphia. Below is a group of students on a class trip as they wait for a train in about 1967. (Above, photograph by and courtesy of William J. Coxey; below, courtesy of Historical Society of Haddonfield.)

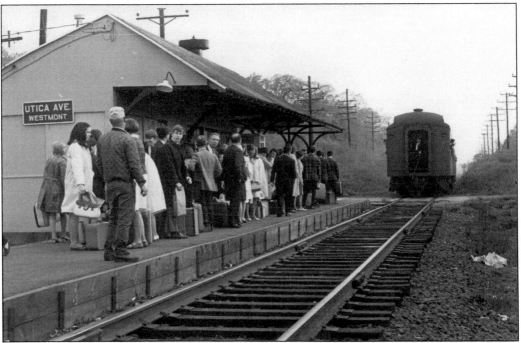

This is a June 1957 view of Crystal Lake Avenue at the Pennsylvania-Reading Seashore Lines' railroad crossing looking west toward Park Avenue. Currently, the PATCO Hi-Speed Line crosses on an elevated structure here. Houses on the left side of Crystal Lake Avenue have all been demolished for the PATCO parking area. (Courtesy of West Jersey Chapter National Railway Historical Society.)

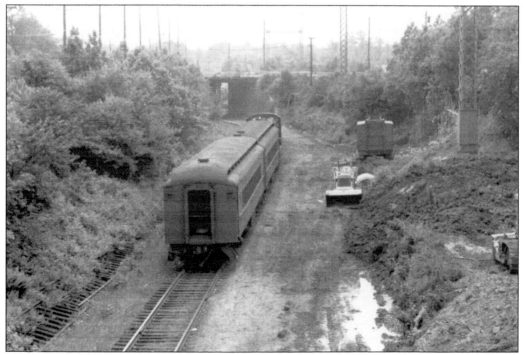

This August 1966 view of the Pennsylvania Railroad is looking toward the Haddon Avenue Bridge from the Maple Avenue Bridge. Note the temporary Haddon Avenue Bridge supports while a new pier is being constructed to accommodate the new alignment of the previous double-track railroad. (Courtesy of Cliff Brunker, H. Gerald MacDonald collection.)

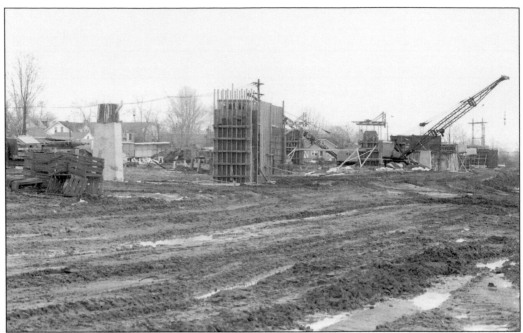

The last Pennsylvania-Reading Seashore Lines' trains between Camden and Haddonfield ran on January 14, 1966, and the track was removed the following month. Construction of the Hi-Speed Line promptly began a short time later, and by the following January, work was progressing along the entire route to Lindenwold. The photograph above, dated January 1967, shows construction on the Westmont viaduct supports; below is a November 1969 view of the completed Westmont Station. The Hi-Speed Line opened to Camden on January 4, 1969, and to Philadelphia six weeks later on February 15, 1969. (Both photographs by and courtesy of William J. Coxey.)

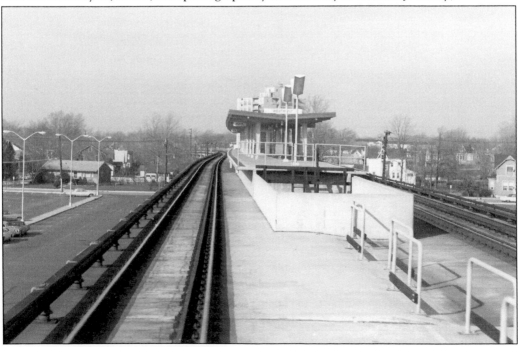

Four
BUSINESS AND INDUSTRY

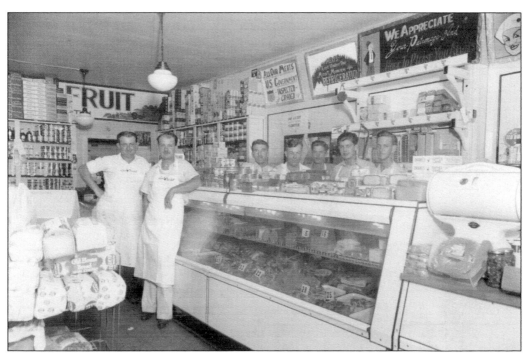

Spot Market was located at 203 Haddon Avenue. This 1940s photograph typifies a small-town, family-run market from that era. Spot Market had a second location on Richey Avenue in West Collingswood. The Haddon Avenue store closed in 1964. (Courtesy of William G. Rohrer Memorial Library, Camden County Library System.)

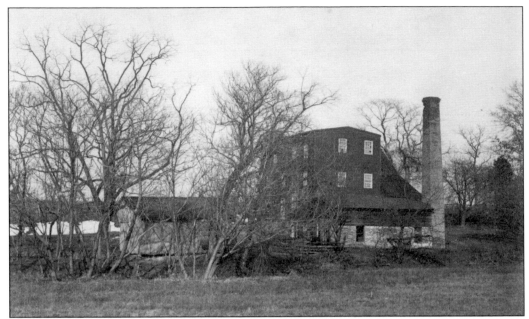

Cuthbert Mill was located on the eastern side of Cuthbert Road, opposite Merrick Avenue. Also known as Newton Mill or Webster's Mill, the gristmill was powered by the waters of Newton Creek. The mill operated for about 100 years, grinding corn and wheat into feed, flour, and meal for local residents. (Courtesy of Historical Society of Haddonfield.)

In the late 18th and early 19th century, Thomas Githens's plaster mill was located along Newton Creek at the boundary of today's Haddon Township and Haddonfield, where Park Boulevard becomes West End Avenue. Plaster was used to improve soil for farming. This print of the mill appeared in an 1830 magazine *The Casket*. (Courtesy of William B. Brahms.)

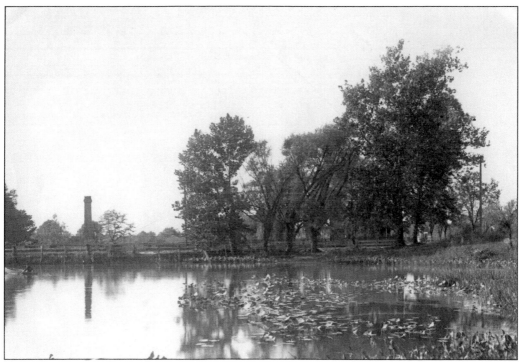

The tall chimney in the background of the above photograph marks the location of Crystal Lake Paint Works, also known as Flinn's Paint Works. The factory was established in 1874 on land sold by John Stoy to James Flinn and John Willits. The Crystal Lake Paint Works manufactured lead and zinc paints and varnish. Its close proximity to the waters of Crystal Lake and Newton Creek was necessary to power water-driven turbines and a steam engine. The plant continued in operation at least into the 1880s. Below is an invoice for products purchased at James Flinn and Company, with an engraving of the Crystal Lake Paint Works in the upper-left corner. (Above, courtesy of William G. Rohrer Memorial Library, Camden County Library System; below, courtesy of Anne and Boyd Hitchner.)

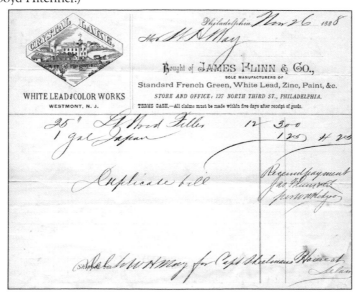

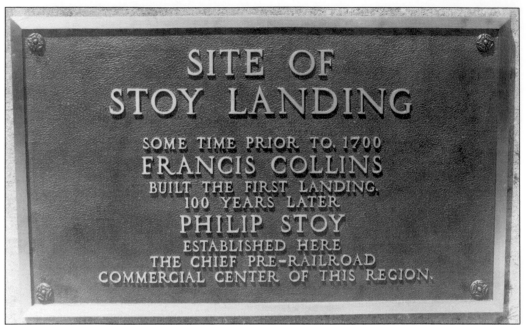

The Stoy Landing plaque on Grove Street at Cooper's Creek designates an important docking area for vessels traveling to and from the Delaware River and Philadelphia into this region. Lumber, manure for fertilizer, and other products were carried and traded at this site near Philip Stoy's property on a hill overlooking Cooper's Creek and within close proximity to today's Jobel Drive. (Courtesy of Historical Society of Haddonfield.)

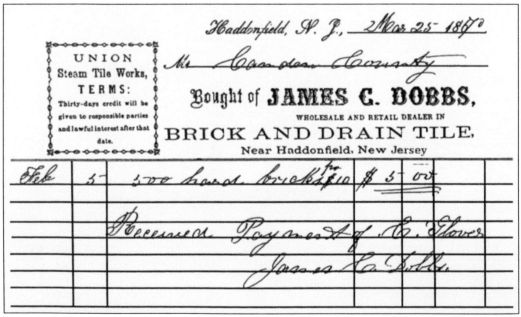

From the 1870s to the early 1900s, Dobbs Brickyard operated just off Cuthbert Road between Lees Lane and the Newton Creek. James Dobbs ran the establishment that produced bricks and clay drainage tiles; the latter was used frequently by farmers to remove excess water from their fields. (Courtesy of Gloucester County Historical Society.)

The David Morgan residence along Cooper's Creek is now known as Hopkins House. Morgan was a photographic paper manufacturer who, in about 1868, pioneered the development of an albumen solution to coat the paper. His paper, created at his Haddon Township facility, had a smooth surface that produced very fine photographic details. Shown here is an 1886 advertisement for his product. (Courtesy of William B. Brahms.)

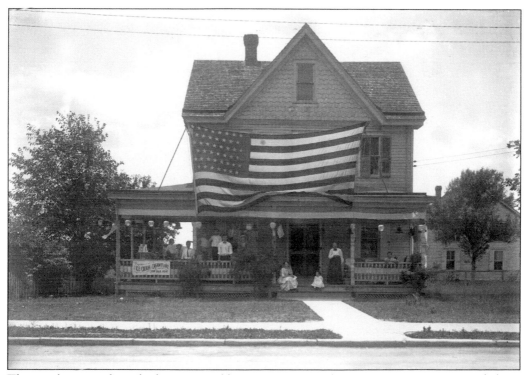

This is a house and candy shop, on Haddon Avenue near Chestnut Street, as it appeared about 1910 to 1920, decorated for a patriotic celebration, most likely a parade on Haddon Avenue. (Courtesy of Art Nunnemaker.)

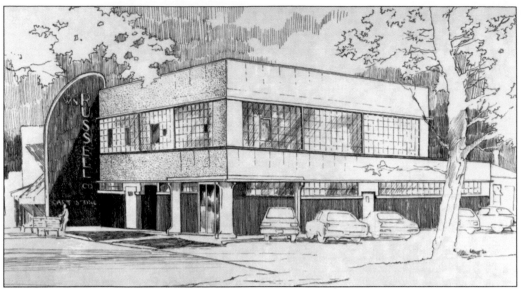

The W.N. Russell Company located on Albertson Avenue was founded in 1921 by William N. Russell Sr. and expanded to a nationwide cast stone firm by his son William N. Russell Jr. Their projects included the visitor center's entrance to the White House, which was designed to match the facade of the Treasury Building across the street. The Russell building was destroyed by fire in 2000. (Courtesy of William N. Russell III.)

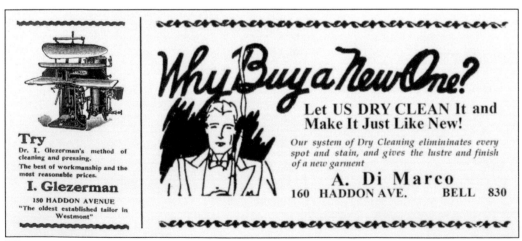

Westmont once was home to five tailors, including Ike Glezerman from Odessa, Russia, and his neighbor Antonio DiMarco from Ripa, Italy. Glezerman was the first tailor and owned only the fifth business in Westmont in the 20th century. DiMarco came from a 300-year tradition of tailors. (Courtesy of William B. Brahms.)

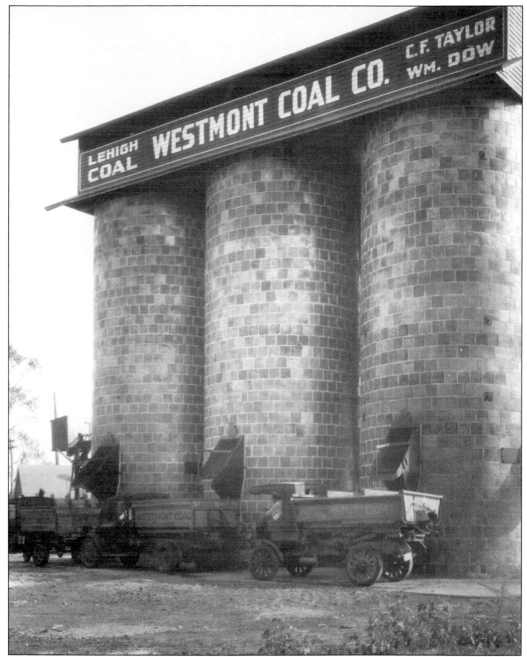

This c. 1925 view of the Westmont Coal Company was captured near the Pennsylvania Railroad at Glenwood Avenue. The coal company was operated by C.F. Taylor and William Dow. During the 1930s, it became Ben's Coal Supply Company and was operated by Ben Kasten. (Courtesy of William C. McKenna.)

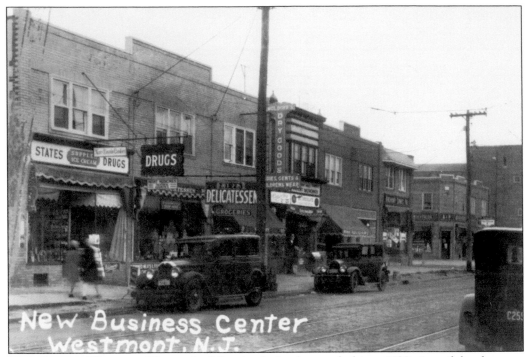

With the new Westmont Theatre building in the background, this c. 1930 view of the shops on Haddon Avenue hails the new business center, including an early Atlantic and Pacific (A&P) grocery store, which is currently occupied by a hair salon at 43 Haddon Avenue. (Courtesy of William C. McKenna.)

This is a c. 1930 view of shops on the White Horse Pike in Haddon Township between Collingswood and East Clinton Avenues. The corner drugstore, later Finnegan's soda fountain, is now 621 White Horse Pike. (Courtesy of Peter Papadeas.)

The Westmont National Bank, located at 144 Haddon Avenue and founded in 1924, was the first bank in town. A robbery of the bank was a major impetus for the formation of the Haddon Township Police Force. The bank was fraught with financial problems and mismanagement, which sent some bank employees to jail. The bank did not survive the early 1930s. (Courtesy of Paul W. Schopp Collections.)

FOR DEPOSIT AT THE

WESTMONT NATIONAL BANK

WESTMONT, N. J.

BY_____

_____19____

PLEASE LIST EACH CHECK SEPARATELY

In receiving items for deposit or collection, this company acts only as depositor's collecting agent and assumes no responsibility beyond the exercise of due care. All items are credited subject to final payment in cash or solvent credits. This company will not be liable for default or negligence of its duly selected correspondents nor for losses in transit, and each correspondent so selected shall not be liable except for its own negligence. This company or its correspondents may send items directly or indirectly, to any bank including the payor, and acce,t its draft or credit as conditional payment in lieu of cash. It may charge back any item at any time before final payment, whether returned or not; also any item drawn on this company not good at close of business on day deposited.

	DOLLARS	CENTS
NOTES		
GOLD.		
SILVER.		
CHECKS AS FOLLOWS		
TOTAL $		

See That All Checks and Drafts are Endorsed

Before the William Getzinger family purchased Westmont Hardware in 1932, it was owned by relatives Philip and Lillian Smith and known as Smith's Hardware, as seen in this c. 1920s photograph. (Courtesy of William Getzinger Sr.)

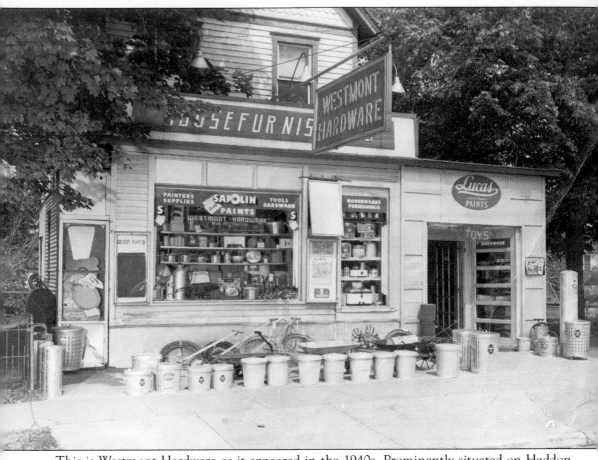

This is Westmont Hardware as it appeared in the 1940s. Prominently situated on Haddon Avenue, Westmont Hardware has been in continuous operation by the Getzinger family since 1932. (Courtesy of William Getzinger Sr.)

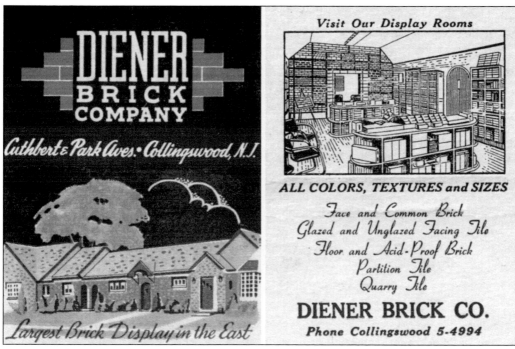

Diener Brick Company, originally L.W. Diener, has had its showroom in Haddon Township on the corner of Park Avenue and Cuthbert Boulevard for over six decades. The elaborate brick-and-stone building in the advertisement from about the 1950s boasts the "Largest Brick Display in the East." (Courtesy of William B. Brahms.)

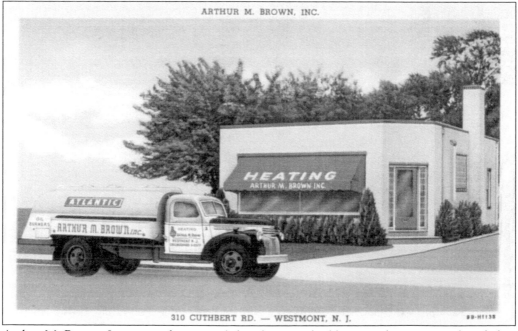

ARTHUR M. BROWN, INC.

310 CUTHBERT RD. — WESTMONT, N. J.

Arthur M. Brown, Inc., was a heating oil distributor and oil-burner sales company founded in 1926. The A.M. Brown building is now a real estate office. Brown's trucks, similar to the one in this 1952 postcard image, were a familiar sight in the area. (Courtesy of William B. Brahms.)

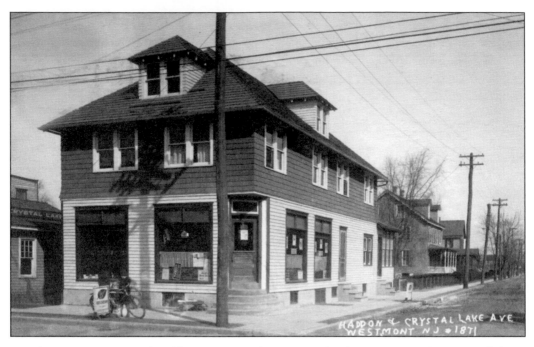

Seen here are two views of Haddon Avenue and East Crystal Lake Avenue. Walt's, pictured above about 1920, was more than a traditional candy and variety store. Walter Weisbrod had aspired to be a pharmacist and sold numerous patent medicines until the patent medicine industry dissipated under stricter government regulations. Walt's also sold cigars, newspapers, and ice cream. As the Depression set in, the store varied its merchandise to improve business, including adding beer taps with the lifting of prohibition. Walt's became a full tavern and, shortly thereafter, changed names, becoming the Crystal Tavern in the 1940s, as seen below. The location has remained a tavern for over 75 years. (Both, courtesy of William B. Brahms.)

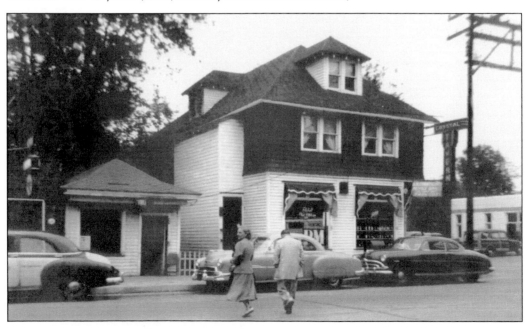

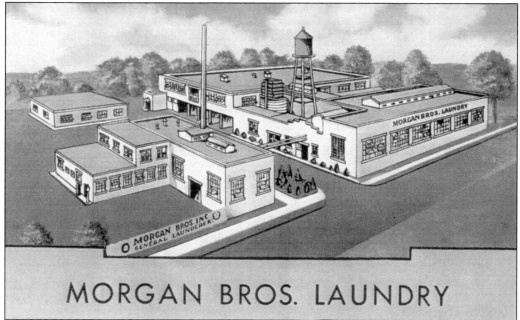

MORGAN BROS. LAUNDRY

Morgan Bros. Laundry, shown in this pre-1950s image, was located at 288 Hyland Avenue. They offered general laundering and dry-cleaning services. The plant later operated as the Dy-Dee Service, Inc., and used the mailing address of 207 Haddon Avenue. Dy-Dee provided sanitary diaper washing and delivery services in the days when all infants wore cloth diapers. (Courtesy of William B. Brahms.)

Franklin P. Jackson III founded the Jackson Funeral Home in 1932 at 9 Chestnut Avenue in Haddon Township. The business's second location at 308 Haddon Avenue, pictured here in 1952, was purchased by Jackson in 1937 and is the current site of the family-owned business. (Courtesy of the Jackson family.)

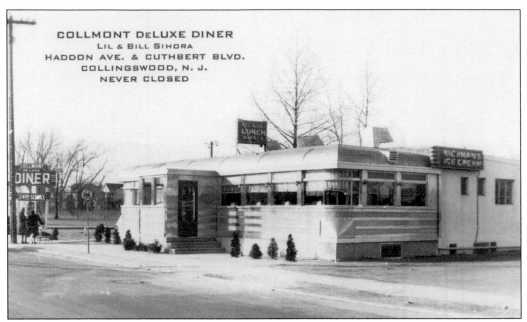

The Collmont Diner was located at the busy intersection of Haddon Avenue and Cuthbert Boulevard. Due to an oddly shaped borderline, the property was in both Collingswood and Haddon Township. Its proximity to the border of Westmont and Collingswood was the inspiration for the name "Collmont." The Collmont not only served as a popular eatery but also became the meeting place for local civic and political organizations, particularly when the building was expanded in the 1950s. A fire in August 1957 destroyed the dining and banquet facilities owned by the William Sikora family of Delaware Township. The diner was rebuilt and remained in business through the 1960s. (Above, courtesy of Steve Watson; below, courtesy of Stan Sheaffer.)

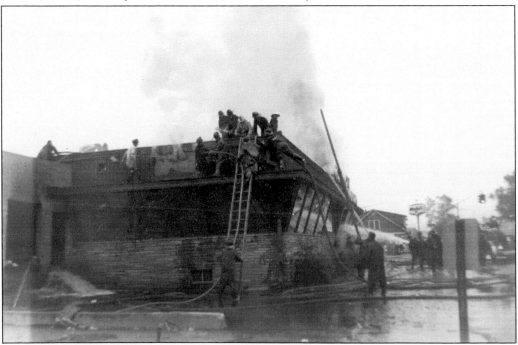

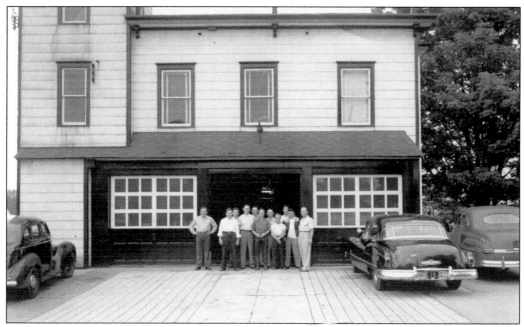

Dr. Frank E. Dudley received acclaim in the 1940s as an expert in the field of radiation control. He also held 38 foreign and domestic patents. Along with his wife, Genevieve Chinn Dudley, Dr. Dudley, shown second from the left in this 1952 photograph, founded the Franklin Manufacturing Company in 1947 in the former Westmont Fire Hall on Center Street. (Courtesy of R. Michael Murray, Esq.)

Pictured is Lay's Market at the corner of Haddon and Strawbridge Avenues next to McMillan's Bakery, with Ralph C. Lay standing in the doorway in the late 1950s. (Courtesy of Thomas W. Owens Jr.)

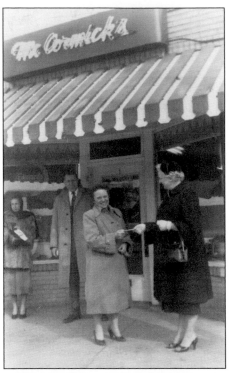

McCormick's shoe store (later Westmont Bootery) was located at the triangular junction of Maple and Locust Avenues at Haddon Avenue. The owners are pictured receiving a Merchant of the Week award sponsored by a local newspaper in about 1965. McCormick's specialized in children's shoes. (Courtesy of Historical Society of Haddonfield.)

Photographed in about 1956 are owners Victor and Ann Pugarelli in Victor's Hardware at 419 Crystal Lake Avenue. The business was later moved to 55 Haddon Avenue until closing in about 2000. (Courtesy of Maria Pugarelli Ginter.)

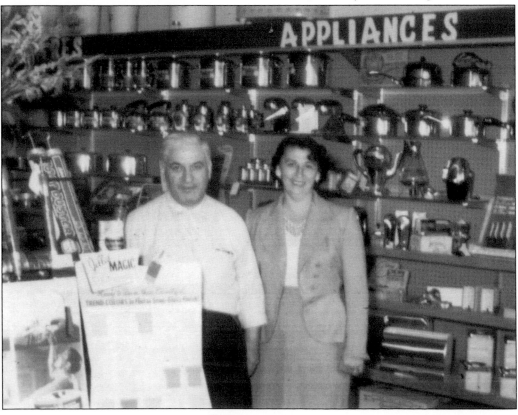

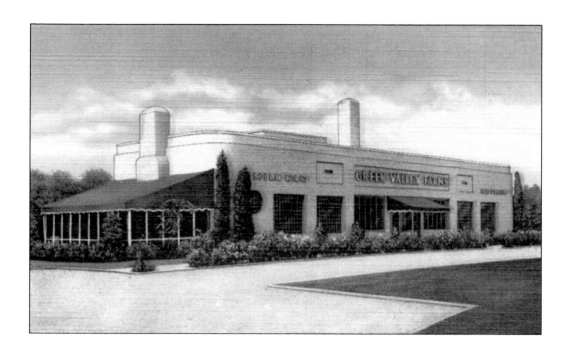

Green Valley Farms served ice cream and sandwiches from the 1930s through the 1970s. Many local residents received their milk, cream, and other dairy products delivered to their house by a Green Valley milkman in the early morning hours. The milkman would place the items in a metal, insulated milk box placed near the house entrance. Empty bottles were left in the box for the milkman to return to Green Valley. The milk was brought in from Burlington County farms and bottled in the Green Valley building. Green Valley was located at 425 West Crystal Lake Avenue on a portion of the farmland previously owned by Daniel Middleton and his daughter Sarah Hunt. Green Valley went out of business in the 1970s, and a series of other restaurants occupied the premises. (Above, courtesy of Sandra White-Grear; below, courtesy of Robert Pierzynski.)

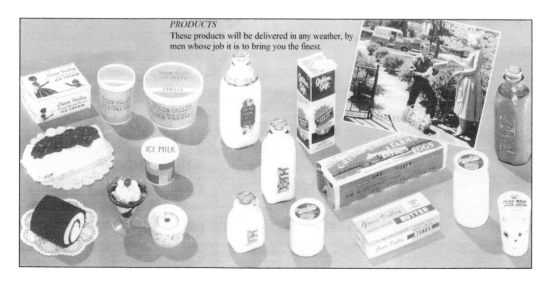

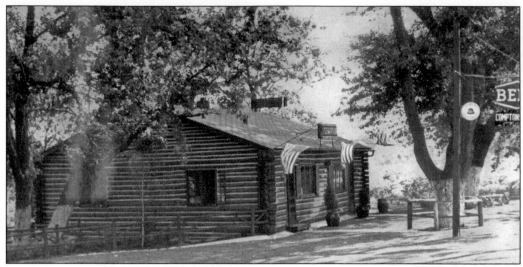

Compton's Log Cabin Restaurant was located on Cuthbert Road at Lee's Lane. Opened in 1936, the restaurant began as a small cabin-style building. Compton's expanded at least twice, and a modern exterior eventually replaced the log cabin style. The Edwin Compton family operated the restaurant until selling the property in 1995. The building was torn down in the 1990s and replaced with a pharmacy. (Courtesy of Cathy Compton Caulfield.)

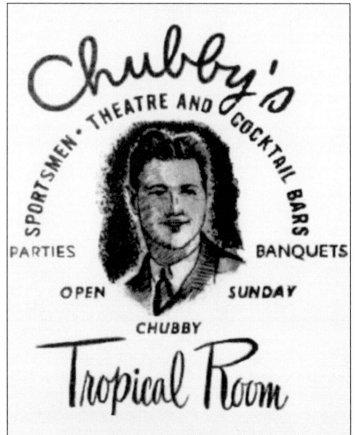

Chubby's restaurant was a popular eatery and entertainment location for over 60 years. Joseph J. "Chubby" Stafford was an amateur boxer who used the Haddon Township location, a wet town amidst many dry ones, to set up Chubby's Cafe, also known as Chubby's Cocktail Bar and Tropical Room. Located at Mt. Ephraim and Collings Avenues, Chubby's drew some of entertainment's biggest names. (Courtesy of Marjorie Wendler.)

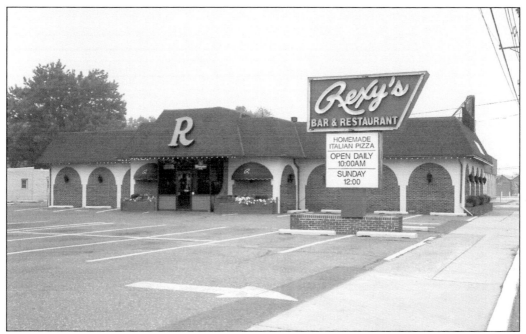

Rexy's Bar and Restaurant at 700 Black Horse Pike in West Collingswood Heights was originally operated by Tony and Pat Fietto. Rexy's established itself as a local landmark and became a favorite spot of many of the great Philadelphia Flyers players of the 1970s and 1980s. (Photograph by and courtesy of Mark Zeigler.)

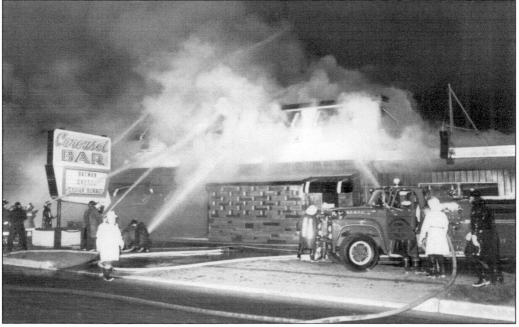

The Carousel Musical Bar was located on Route 130 in West Collingswood Heights. The photograph above, taken April 11, 1966, shows West Collingswood Heights firefighters battling the blaze that destroyed the popular venue. (Photograph by and courtesy of Bob Bartosz, Camden County fire photographer.)

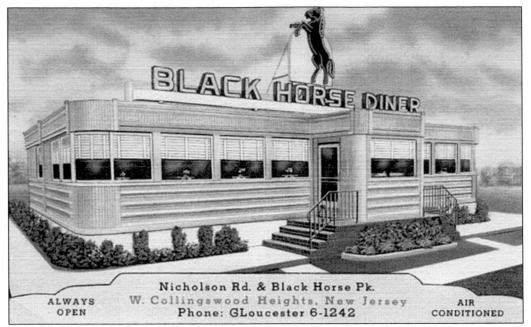

Nicholson Rd. & Black Horse Pk.

ALWAYS
OPEN
W. Collingswood Heights, New Jersey
Phone: GLoucester 6-1242
AIR
CONDITIONED

The original Black Horse Diner sat at the southwest corner of the intersection of the Black Horse Pike and Nicholson Road. (Courtesy of William B. Brahms.)

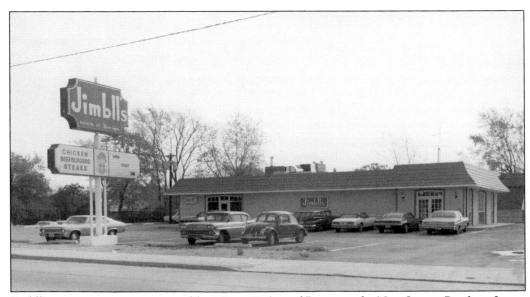

Jimbll's was a restaurant operated by Mister Softee of Runnemede, New Jersey. Brothers James and William Conway founded Mister Softee, a mobile ice cream–vending company, in 1956. The brothers expanded into the restaurant business in about 1968. Their Haddon Township restaurant was located at 8 Haddon Avenue. (Courtesy of Mister Softee, Inc., Runnemede, New Jersey.)

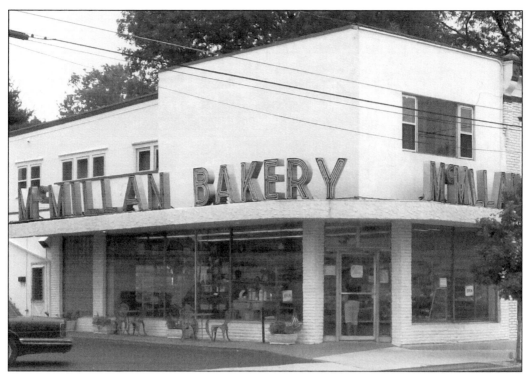

George and Evelyn McMillan opened McMillan's Bakery in 1939. Now in operation by the third generation of the family, McMillan's, located at 14 Haddon Avenue with its distinctive neon exterior sign, is regarded as a premier bakery serving Haddon Township residents and loyal clientele from neighboring communities. (Photograph by and courtesy of John Flack Jr.)

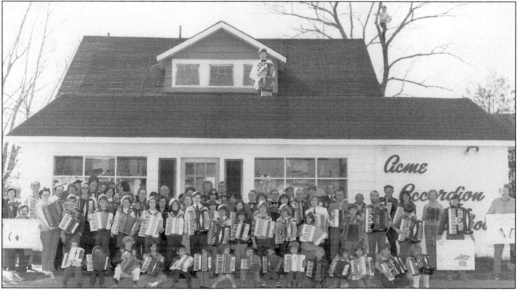

The Acme Accordion School was established in 1948 by Stanley and Sherrie Darrow. At that time, the school was located at 136 Haddon Avenue. In 1960, they moved to their present location at 322 Haddon Avenue. Currently run by Stanley and Joanna Darrow, the school celebrates over 60 successful years in Haddon Township. (Courtesy of Joanna Darrow.)

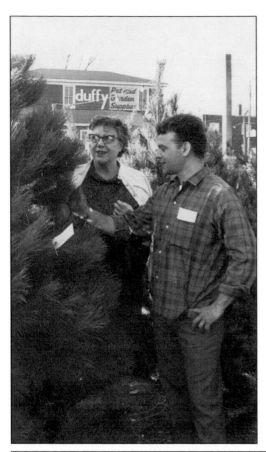

The James J. Duffy and Son (J. Richard Duffy) garden and pet supplies store was located at 222–230 Haddon Avenue. A large parking lot extended to Crystal Lake Avenue and was the site of their annual Christmas tree sale, as shown in the undated photograph at left. The 1982 image below was taken shortly before Duffy's was demolished. An office building presently occupies the former Duffy's property. (Both, courtesy of Historical Society of Haddonfield.)

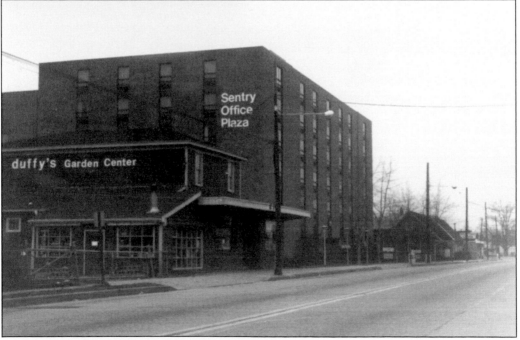

Sattler's was opened by William Sattler and his wife, Eleanor, as a home-based distributor for American Flyer Trains. The Haddon Avenue store followed in 1954, later specializing in HO model trains and accessories. After William died, Eleanor took over. After her death, longtime employee and store manager Bruce Kohler continued running the business. (Photograph by and courtesy of Mark Zeigler.)

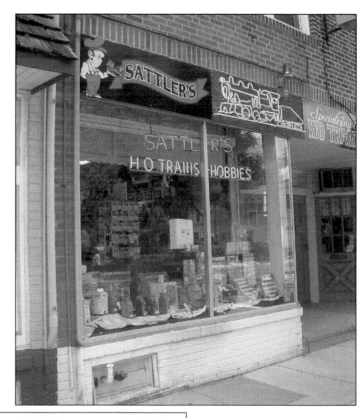

William G. Rohrer launched the First People's Bank of New Jersey in 1956 and served as president and chief executive officer for 26 years. In 1965, the bank opened its flagship office and headquarters at the corner of MacArthur and Cuthbert Boulevards. By 1976, the First People's Bank of New Jersey had over 30 locations, offering free checking and Saturday hours. In 1992, the bank merged with New Jersey National Bank. (Courtesy of William B. Brahms.)

Jack Segal Upholstery was started by Jack and Grace Segal in 1948. Located at 28 Nicholson Road in West Collingswood Heights, the business grew with additions made during the 1950s. After Jack's death in 1971, the business changed ownership and was renamed Tomaselli's Upholstery, later known as Lake's Upholstery. (Courtesy of Carol Segal Swanson.)

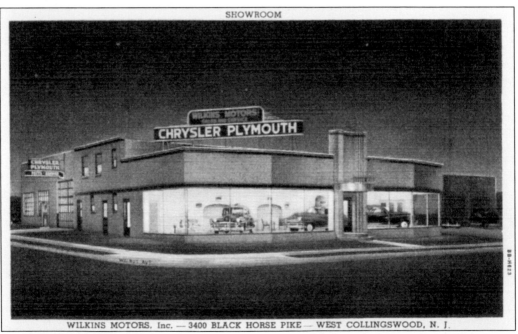

Pictured in the 1950s is Wilkin's Motors at 3400 Black Horse Pike at the junction of Routes 168 and 130. For over 50 years, Chrysler-Plymouth dealerships were at this location. In the early 1960s, it became Jefferies Garden State Motors and was later Dunphy, then Lenihan. It is now the Black Horse Autopen and deals in used automobiles. (Courtesy of Marjorie Wendler.)

Five

RECREATION AND ENTERTAINMENT

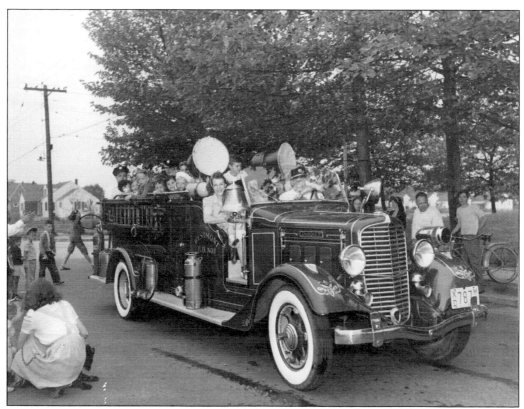

A long tradition and special treat for Haddon Township children was a ride around their neighborhood in a fire truck. Shown here about 1950 is the 1933 Diamond T Utility Wagon fire truck. (Courtesy of Westmont Fire Company Collection.)

In this 1909 photograph are Samuel Nicholson Rhoads and his son Evan Lawrie Rhoads standing by Cooper's Creek near Coles Mill Road. The railroad bridge can be seen in the distance. (Courtesy of Historical Society of Haddonfield.)

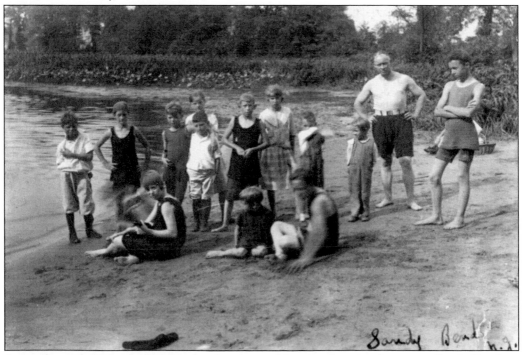

A popular early-20th–century local swimming and boating location known as Sandy Bend on Cooper's Creek (later Cooper River) is shown. (Courtesy of William G. Rohrer Memorial Library, Camden County Library System.)

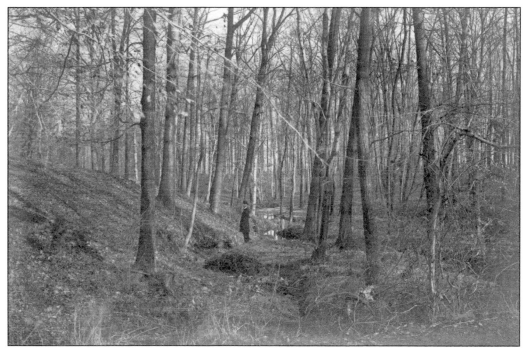

This 1899 photograph is identified as "Doyle's Woods." John Doyle of Camden purchased the 120-acre estate of John Mickle Whitall, which was located near present-day MacArthur Boulevard. Some of the woodlands of the estate have been preserved today and renamed Saddler's Woods. (Courtesy of Historical Society of Haddonfield.)

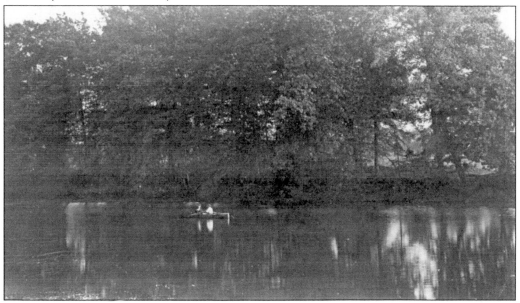

This 1907 photograph offer a unique view of boaters enjoying the peaceful beauty of Cuthbert Lake. The source of the waters of Cuthbert Lake was the Main Branch of Newton Creek, which begins in Haddonfield and flows to the Delaware River. At one time situated on the eastern side of Cuthbert Road, the creek was piped underground or rerouted by the early 20th century, and the Cuthbert Lake bed was filled in for housing development. (Courtesy of William C. McKenna.)

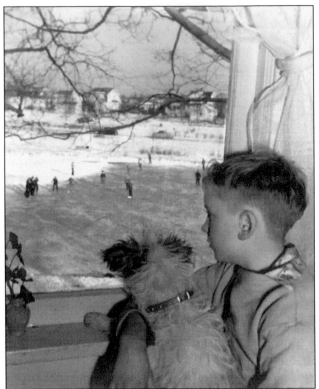

From his second-floor vantage point, young Robert McCarthy and Queenie watch ice-skaters on Newton Lake in about 1940. The McCarthy residence was on Oaklawn Avenue at the border of Oaklyn and Haddon Township. Newton Lake flows through the communities of Haddon Township, Collingswood, and Oaklyn. (Courtesy of Robert McCarthy.)

Edison Woods is the local name for the woodlands near Edison School. As evidenced by this 1910 photograph, Edison Woods has served as an area for nature studies, as well as a favorite passive recreational area frequented by Haddon Township residents for over 100 years. (Courtesy of William G. Rohrer Memorial Library, Camden County Library System.)

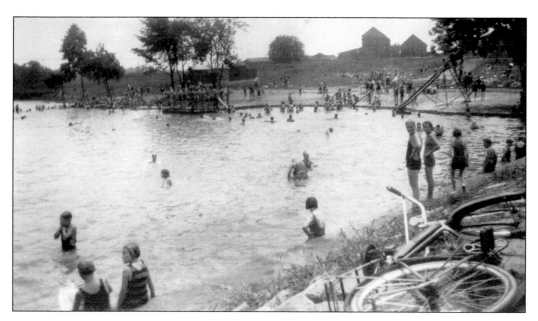

During the 1930s, work began on transforming a portion of Crystal Lake, a longtime swimming location, into a more functional pool. Old curbing material from the Bluebird community was used to build a retaining wall around the perimeter of the new pool, which extended from Carlton Avenue to Crystal Lake Avenue. Lifeguards, initially police officers who volunteered, used rowboats to patrol its length. In September 1937, the Works Progress Administration (WPA) began work on a comfort station, refreshment stand, tennis courts, and first-aid station. On July 4, 1938, during Haddon Township's first annual Independence Day celebration, residents also celebrated the opening of the new bathhouse/refreshment stand called the Nautical House. The photograph above shows children enjoying the pool about 1932. The image below was captured in the early 1940s, before the Haddon Hills Apartments were built. (Above, courtesy of Haddon Township Police Department; below, courtesy of Steve Watson.)

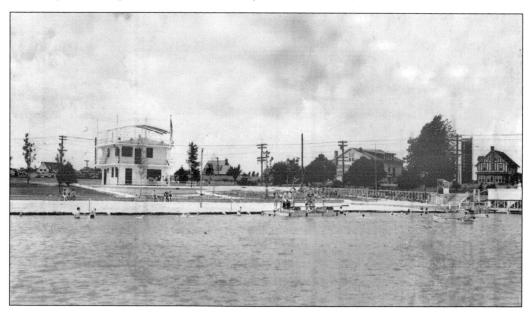

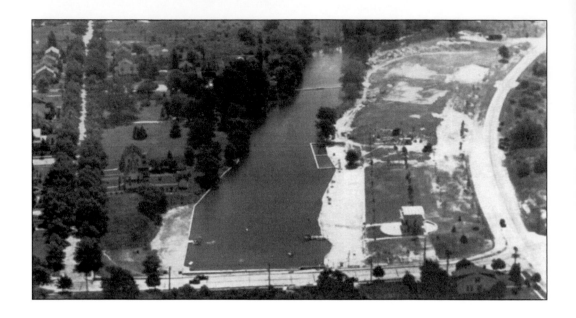

The photograph above is an aerial view of the lake and pool in the 1940s. By the 1950s, Crystal Lake Pool no longer extended to Carlton Avenue, as seen below. An earthen dam and drainage pipes redirected the lake waters. A cement t-dock and high-dive platform were among several new features added over the years. The pool continued to feature a sandy bottom, with a sand beach area near the t-dock and kiddie pool area. (Both, courtesy of William G. Rohrer Memorial Library, Camden County Library System.)

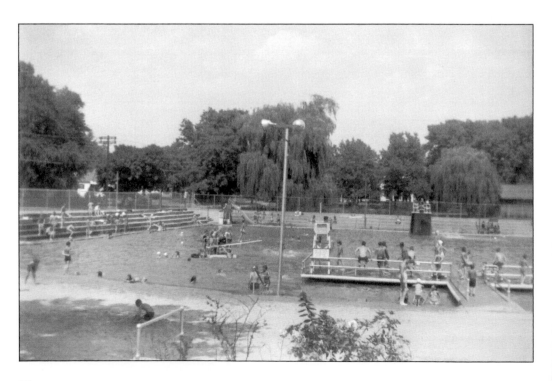

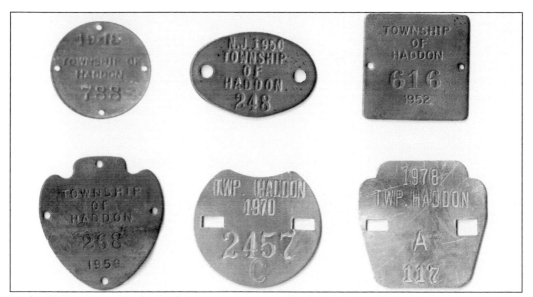

In the 1930s, Crystal Lake Pool season passes cost 50¢ for adults and 25¢ for children under 14. Pool tags started as coins in 1931 and evolved to be sewn on to bathing suits. These pool tags are from the 1940s to 1970s. The earlier tags were made of brass, while later ones were constructed from aluminum, followed by plastic. (Courtesy of William B. Brahms.)

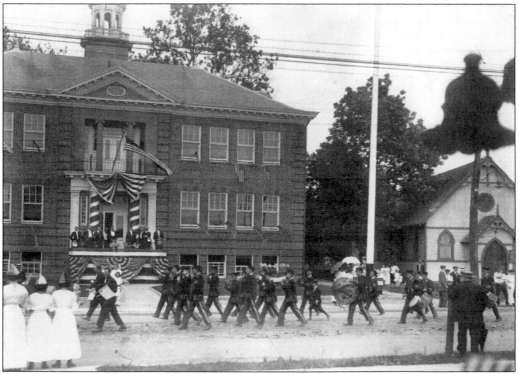

Parades have been a long tradition in Haddon Township. This c. 1910–1915 parade in front of the Westmont School on Haddon Avenue appears to have taken place in the summer and may have been an Independence Day celebration. (Courtesy of William G. Rohrer Memorial Library, Camden County Library System.)

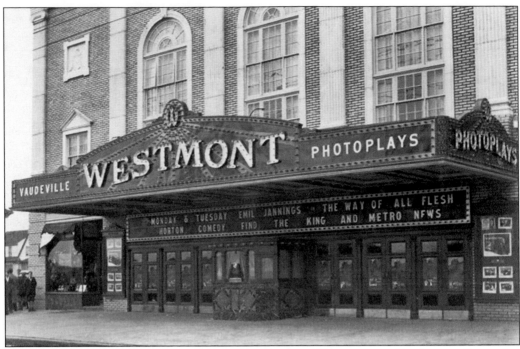

Situated prominently at 49 Haddon Avenue, the Westmont Theatre opened its doors on September 5, 1927, under the management of Handle-Rovner Amusement Enterprises. The magnificent $400,000 theater, featuring an ornate marquee built by the Philadelphia Sign Company, boasted a seating capacity of 1,800. The theater, shown above in 1929, was built during the waning years of the Vaudeville era and silent films. It had an elaborate, custom-built organ worth over $25,000. The console included many complicated stops to create special sound effects. Below is an advertisement card for an event at the Westmont Theatre on May 22, 1929. Along with Westmont's American Legion band's performance was the screening of *Seven Footprints to Satan*. The 1929 film was a dark comedy produced as a silent film and a partial talkie. (Above, courtesy of Robert Mehmet, Philadelphia Sign Company; below, courtesy of Stan Sheaffer.)

DEAR FRIEND:—
We are proud to announce the personal appearance of the
BUGLE, FIFE and DRUM CORPS
35 — STRONG — 35
of the
ALLEN IRVIN MORGAN POST, No. 230, AMERICAN LEGION
WESTMONT, N. J.
In Addition To Our Regular

5 SELECT ACTS VAUDEVILLE
IN CONJUNCTION WITH
"SEVEN FOOTPRINTS TO SATAN"
With THELMA TODD, CREIGHTON HALE, SHELDON LEWIS and Others
WEDNESDAY, MAY 22nd
WESTMONT THEATRE
Westmont, N. J.

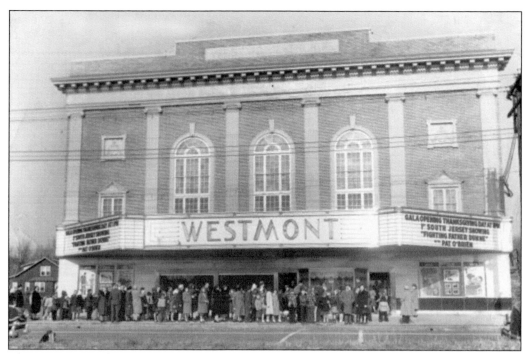

The Westmont Theatre remained open into the Great Depression. Live vaudeville acts were presented at the theater into the early 1930s. By the mid-1930s and during World War II, the theater closed operations altogether. The theater reopened on Thanksgiving Day, November 25, 1948, as part of the Varbalow chain of theaters (the Varbalow chain later became the Savar Corporation). It was completely remodeled with a design by David Supowitz. The photograph above shows the newly redesigned Westmont Theatre. During this period, Eli M. "Emo" Orowitz was the district manager for Varbalow, and his son Eugene Orowitz (later known as Michael Landon) worked for a short time at the Westmont Theatre as a doorman. The Orowitz family lived nearby in Collingswood. The photograph below shows Eli Orowitz in the ticket booth at the Westmont Theatre. (Both, courtesy of Allen F. Hauss.)

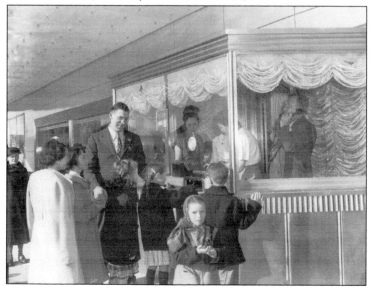

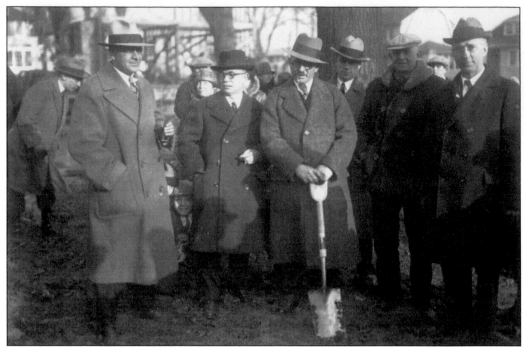

The Ritz Theatre was built as part of the William E. Butler and Son chain of theaters. The Ritz opened on September 12, 1927, showing Marion Davies in *Tillie the Toiler*. A total of 1,200 people attended the first day's showings. The theater originally had a capacity of 800. A $25,000 orchestration organ designed to replicate the sounds of a full symphony orchestra provided music in the theater. The total cost of the theater was estimated at $400,000. The photograph above shows the ground breaking for the Ritz Theatre in 1927. Below is a 1934 view of the theater on the White Horse Pike. (Above, courtesy of Doris Linderman Palmer; below, courtesy of Edward Coyle.)

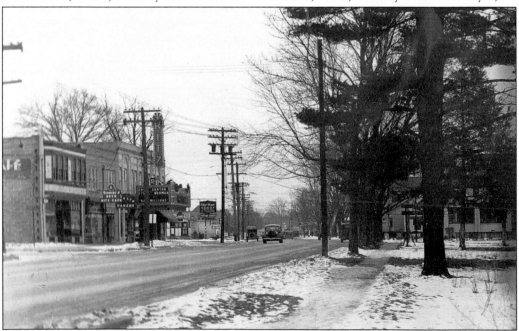

The Crescent Theatre, shown as it appeared in 1941, was located on Mount Ephraim Avenue. Opened in 1929, this was the third vaudeville-era movie house to open and simultaneously operate in Haddon Township. It closed in the 1970s. The building became an automobile-and-tire repair center. (Courtesy of Allen F. Hauss.)

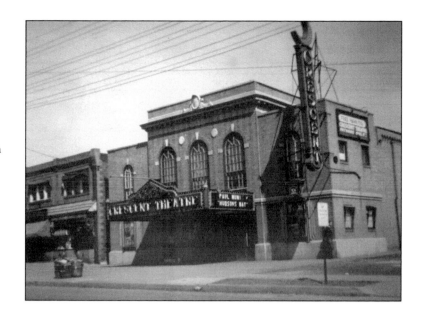

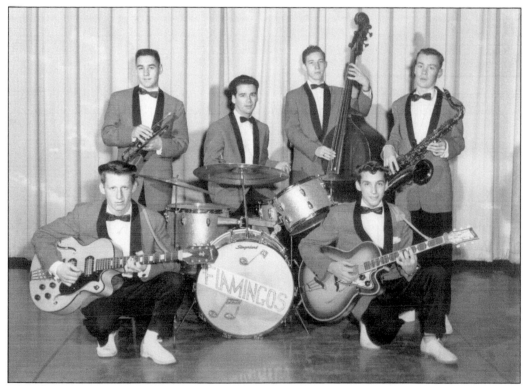

The Flamingos, from left to right, are Bill Ludwick, guitar (first row); Ralph Crane, guitar (first row); Jim Reid, trumpet; Mike Murray, drums; Ed Shields, bass; and Ray Goebel, saxophone. The Flamingos (1958–1961) played for the Teen Canteen dances, a project founded by Bernice Getzinger, along with the sponsorship and full support of the Haddon Township Police Department. (Courtesy of R. Michael Murray, Esq.)

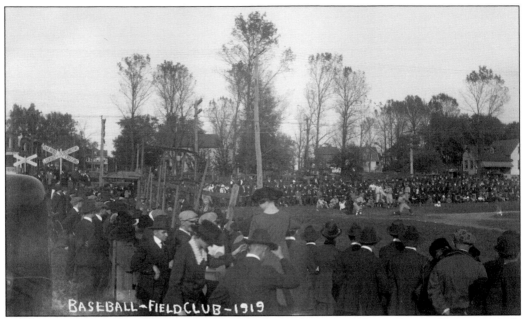

BASEBALL-FIELD CLUB-1919

Organized in 1914, the Westmont Field Club, shown here in 1919, was located approximately between Glenwood (near the railroad crossing) and Crystal Lake Avenues in the vicinity of Ardmore, Haddon, and Westmont Avenues. Teams competing in field club play represented organizations, neighborhoods, and nearby towns. Target and skeet-shooting competitions were also held at the field club. (Courtesy of Art Nunnemaker.)

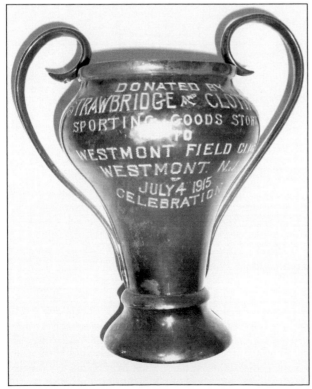

Shown is a loving cup trophy awarded to the Westmont Field Club on July 4, 1915. The trophy was donated by Philadelphia merchants Strawbridge and Clothier. (Courtesy of William B. Brahms.)

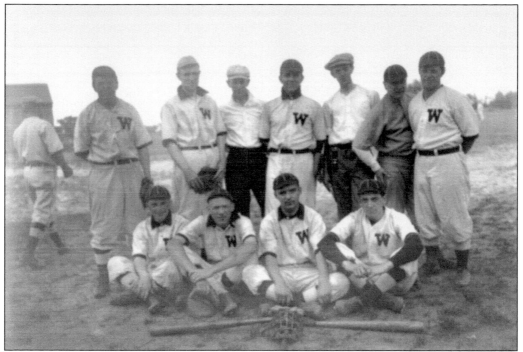

Before baseball leagues took hold as a youth sport, local teams were made up of adult participants. Several leagues and teams came and went before World War I, winding down by World War II. Most teams represented townships or organizations. This Westmont team dates to about 1910 to 1920. (Courtesy of William G. Rohrer Memorial Library, Camden County Library System.)

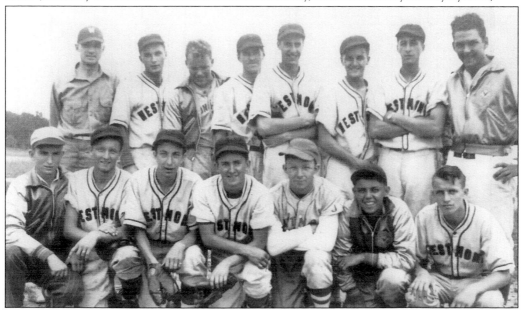

The members of the 1939 Westmont Eagles baseball team were, from left to right, (first row) Ed Truitt, Jim Smith, Jack Neu, Frank Larossi, Rusty String, Lou Springer, and Al Neu; (second row) manager Charles Mayer, Bill Wright, Dave MacMillin, Jess Horton, Wade Locke, Vic Morganstern, Fran Oberhaus, and Bill Payne. (Courtesy of Al Neu.)

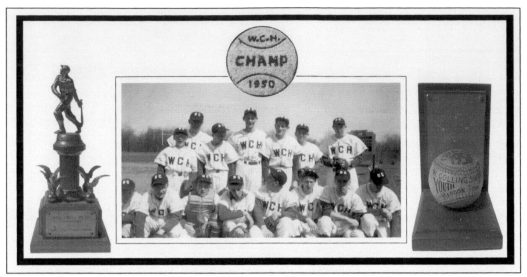

In the early years of organized youth baseball in Haddon Township, West Collingswood Heights fielded a team with many sponsors, including Rexy's and Rohrer Chevrolet. Haddon Township police were involved in administering the league. The West Collingswood Heights team was the 1950 champion. (Courtesy of Mark Zeigler.)

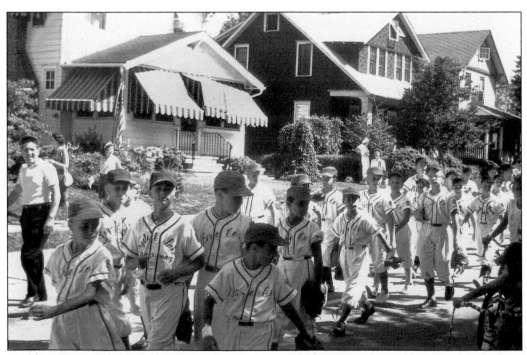

Haddon Township Little League baseball team members march in the annual Fourth of July parade on Crystal Lake Avenue in about 1962. (Courtesy of Anita Geismar, Edward V. Geismar Collection.)

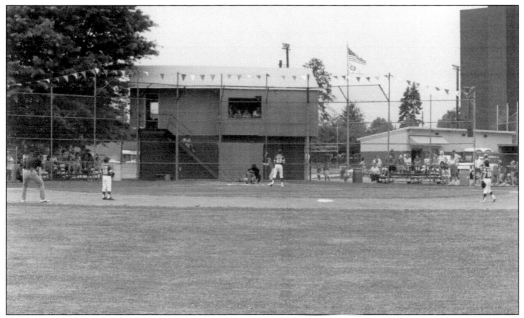

Youth baseball and Little League in Haddon Township dates back to just after World War II. Early Westmont teams in the 1950s included Westmont Fire Company and Westmont Lions—both of which still sponsor teams. They were also joined by Morgan Bros., Duffy's Feed, and others. Among the longest sponsoring businesses are Westmont Hardware and Hardenbergh Insurance. The Haddon Township Athletic Association (HTAA) was incorporated formally around 1961. The old field house and concession stand that stood for decades is visible in the background of the photograph above. A modern complex has replaced it. Pictured below is the HTAA 12-years-and-under team, which won the state championship in the Babe Ruth league division in 1996. (Both, courtesy of Haddon Township.)

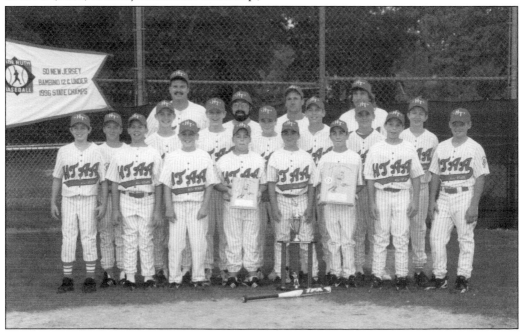

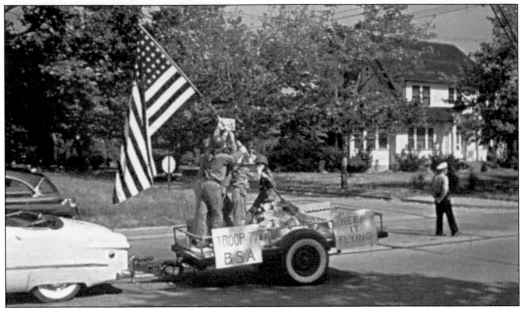

This 1950s view of the Boy Scouts of Troop 79 shows them reenacting the raising of the flag at Iwo Jima as part of their troop's float display in the annual Fourth of July parade. They are marching on Cuthbert Boulevard near the intersection of Oriental Avenue. (Courtesy of Carol Schafer Sweeney.)

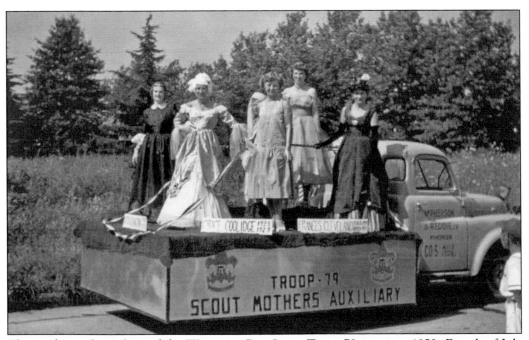

The mothers of members of the Westmont Boy Scout Troop 79 join in a 1950s Fourth of July parade on Cuthbert Boulevard dressed as the wives of American presidents. Roseann Schafer (back row, far right), wife of scoutmaster Charles F. Schafer, is dressed as Mamie Eisenhower. (Courtesy of Carol Schafer Sweeney.)

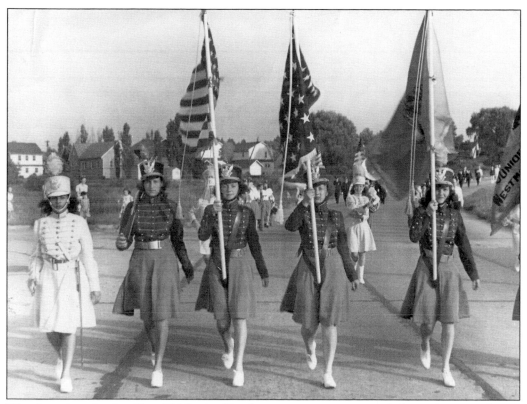

The American Legion Post 230 Junior Band was very active, particularly in the years during and after World War II. They participated in parades in Haddon Township and surrounding communities, including the annual Memorial Day parade on Haddon Avenue from Haddon Township to Harleigh Cemetery in Camden. Practices were held at the wide, paved but largely unpopulated streets near Stoy School. The American Legion Post 230 headquarters was located on Reeve Avenue. In the photograph above are, from left to right, Jean Tirro, Betty Van Horn, Florence Tirro, Barbara Holzinger, and Althea Kincade. (Both, courtesy of Haddon Township Police and Westmont Fire Company Collections.)

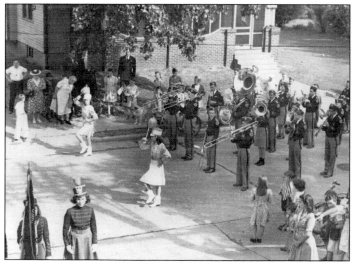

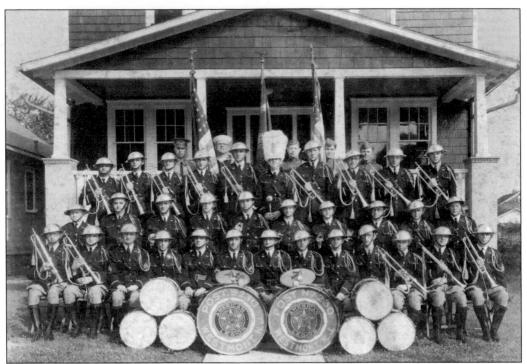

The American Legion Band, which began in the post–World War I years as a bugle, fife, and drum corps, participated in many band concerts and parades throughout the local area. Shown in this 1928 photograph in front of the American Legion Post 230 headquarters on Reeve Avenue, the band was a strong participant in the annual Memorial Day march to Harleigh Cemetery to honor Haddon Township veterans. (Courtesy of Haddon Township Police and Westmont Fire Company Collections.)

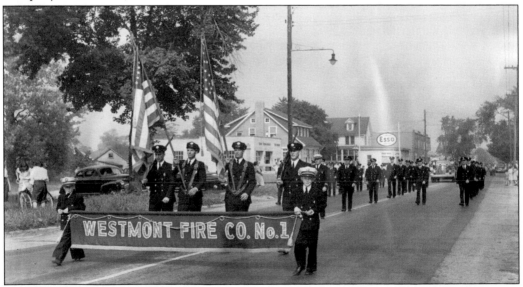

The Westmont Fire Company is shown marching on Haddon Avenue in about 1950. The service station in the background was located at 26 Haddon Avenue. It is currently occupied by Cook's Liquor Store. (Courtesy of Westmont Fire Company Collection.)

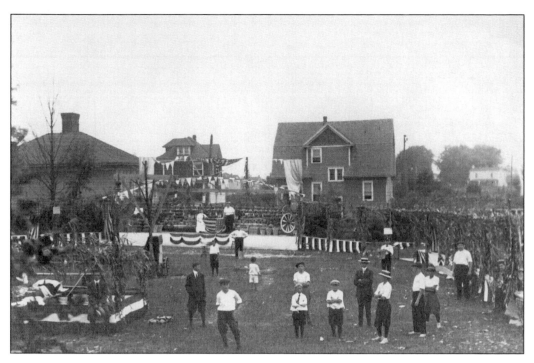

The Westmont Fire Company hosted an annual two-day country circus from at least 1913 and for many years after. The fairgrounds were decorated with bunting, lanterns, and cornstalks. Wagons brought produce from nearby farms to be exhibited. Booths and tables were set up on vacant land opposite the Westmont Fire Hall. The photograph above shows the fairgrounds with booths and decorations set up on Center Street (with houses on Reeve Avenue in the background). Below, tobacco products served as prizes at one of the game tables. (Above, courtesy of the Westmont Fire Company Collection; below, courtesy of William G. Rohrer Memorial Library, Camden County Library System.)

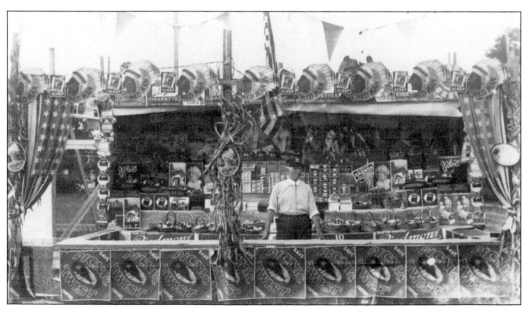

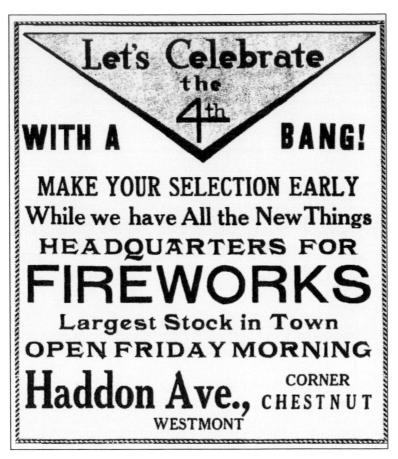

Let's Celebrate
the
4th

WITH A BANG!

MAKE YOUR SELECTION EARLY
While we have All the New Things
HEADQUARTERS FOR
FIREWORKS
Largest Stock in Town
OPEN FRIDAY MORNING
Haddon Ave., CORNER CHESTNUT
WESTMONT

Fireworks for the Fourth of July were once openly advertised and sold, as evidenced by this 1920s advertisement offering the dangerous items for sale directly across the street from the old Westmont School (present location of Haddon Township Municipal building). (Courtesy of William B. Brahms.)

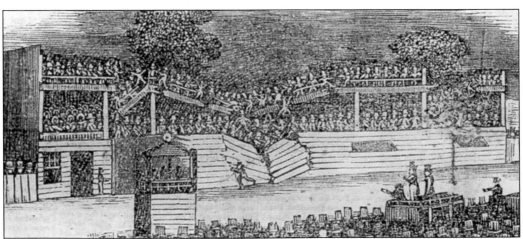

The Camden and Philadelphia Race Course began in 1835 when several prominent figures in horse racing came from Virginia and purchased a farm from Samuel C. Champion. However, the racecourse drew con artists and thieves, causing local citizens to call for its removal. In 1845, the grandstand collapsed during a race, killing three and injuring dozens. In 1847, the property was sold. Shown is an 1845 engraving of the grandstand collapse. (Courtesy of Camden County Historical Society.)

Six

COMMUNITY

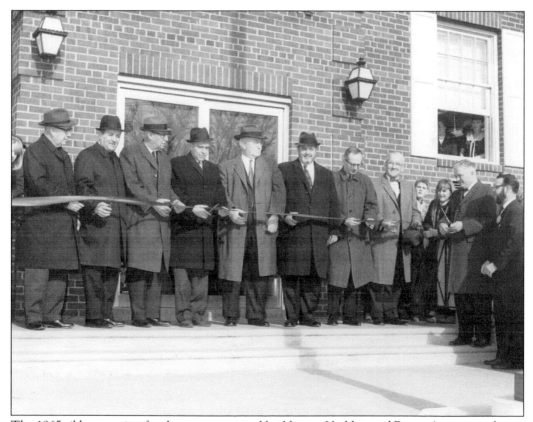

The 1965 ribbon cutting for the new municipal building at Haddon and Reeve Avenues is shown here. Participating in the ceremony were mayors of the towns that were part of Haddon Township in 1865. From left to right are the mayors of Audubon, Audubon Park, Collingswood, Haddonfield, Haddon Heights, Haddon Township, Oaklyn, and Woodlynne, with state senator Fred Scholz holding the end of the ribbon. (Courtesy of Haddon Township.)

WESTMONT (PACER) AND RUNNING MATE, 2:01¾.

In the 1880s, the village locally known as Glenwood petitioned for a post office. A committee searched for a unique postal village name, as Glenwood was taken elsewhere in New Jersey. When four jubilant men arrived at the committee meeting after having just won $100 each on the failure of the famed pacer horse Westmont to run under a certain time, the name Westmont was agreed upon. (Courtesy of William B. Brahms.)

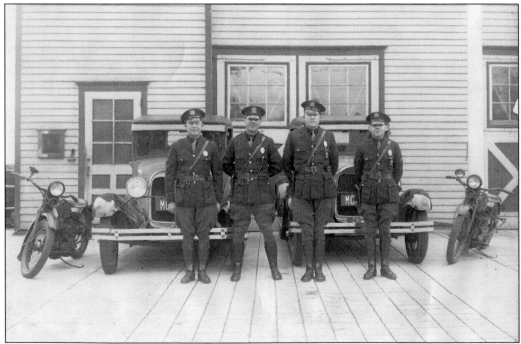

The first police force in Haddon Township was organized on June 1, 1926. A holdup at the Westmont National Bank was the motivation for establishing the police department. By 1929, when this photograph was taken, the town officers were, from left to right, William Snyder, Chief Horace Whitehead, Charles "Reds" Craig, and William Gorman. The police station was located behind the Westmont Firehouse on Highland Avenue. (Courtesy of Haddon Township Police Department Collection.)

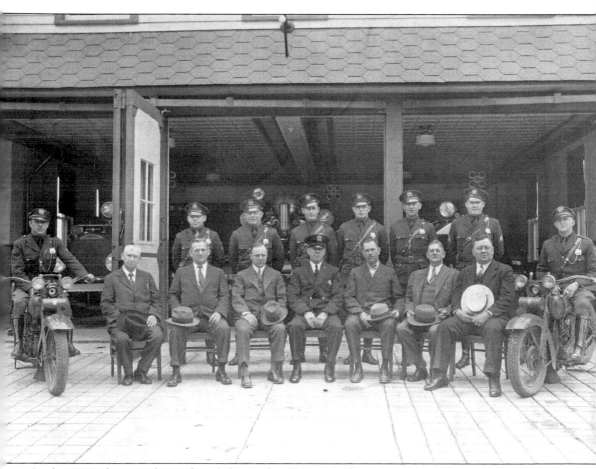

In this 1930 photograph are, from left to right, (first row) officer George Schuck, township clerk Richard Griffith, tax collector J.S.C. Williams, township committeeman M. Ray Boyer, chief of police Horace Whitehead, chairman of the township committee Alexander P. Schunemann Jr., township committeeman Edward W. Russell, tax assessor Edward J. Wintering, and officer George Locke; (second row) officers William Gorman, William Snyder, James Spillane, William Hurff, and John Simon and Sgt. Charles Craig. (Courtesy of Haddon Township Police Department Collection.)

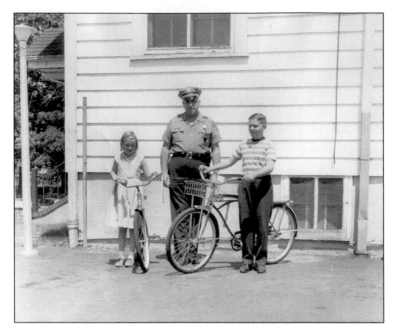

In this c. 1965 photograph, Haddon Township police sergeant Adolph Oehlers instructs local youths on bicycle safety at the police headquarters on Reeve Avenue. Sergeant Oehlers also worked with students in the safety patrol program and other events for township children. (Courtesy of Haddon Township Police Department Collection.)

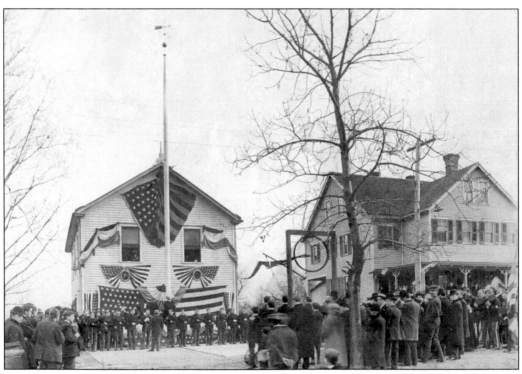

The Westmont Fire Company was incorporated with 31 members in 1902. The first fire hall, located on Center Street, was built in 1905. This photograph of the flag-draped firehouse was taken on Thanksgiving Day in 1907. The tire rim of a Pennsylvania Railroad locomotive wheel was mounted on two poles, as seen in the center of photograph, and served as Westmont's first fire alarm. (Courtesy of Westmont Fire Company Collection.)

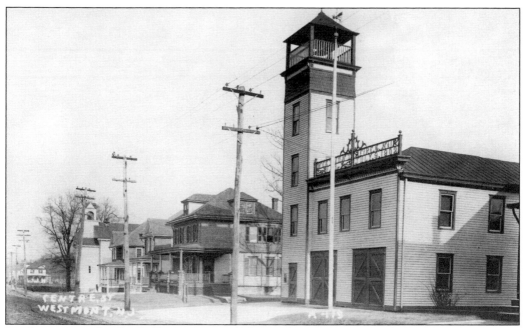

In about 1909, the fire hall was too small for modern equipment. The building was moved to the back of the lot, and an addition with a tower to dry the hoses was built in front. The photograph, from about 1915 to 1920, shows the new fire hall. The building remained the same until it was again altered to accommodate new equipment in 1929. (Courtesy of Westmont Fire Company Collection.)

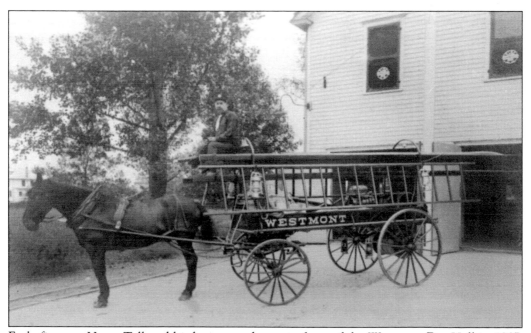

Early fireman Harry Tull and his horse are shown in front of the Westmont Fire Hall in 1907. Tull wears the company uniform of black shirt and white tie that was adopted in 1907. (Courtesy of Westmont Fire Company Collection.)

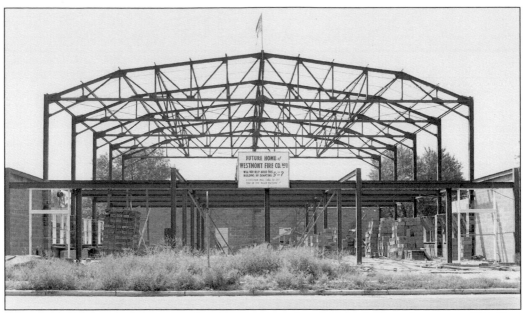

October 2, 1948, marked the official ground breaking for a new fire hall on the corner of Haddon and West Walnut Avenues. The building was dedicated on June 14, 1952, to coincide with the 50th anniversary of the Westmont Fire Company. In 1952, the company included over 100 volunteers. (Courtesy of Westmont Fire Company Collection.)

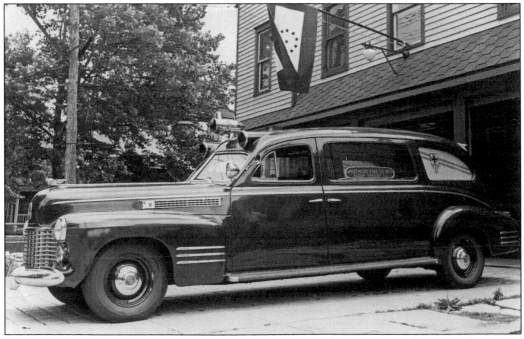

Ambulance service in Haddon Township began on June 9, 1941. Westmont and West Collingswood Heights both offered membership cards for donors. A yearly membership of $1 entitled Haddon Township residents to service within a hundred-mile radius, 24 hours a day, seven days a week. There was no charge for equipment on hand, including hospital beds, oxygen tanks, face masks, and crutches. (Courtesy of Westmont Fire Company Collection.)

№ 12

Name _EDWARD WEBER_

Address _8 LINCOLN AVE W. Coll. Hts_

SPONSORED BY
WEST COLLS. HTS. FIRE COMPANY NO.1
For use of Residents of 4th Fire District, Haddon Township

1963

(OVER)

The West Collingswood Heights Fire Company was incorporated on August 3, 1923. Their first equipment was a two-wheeled hose reel that was pulled by horses or men. In 1925, they purchased a motorized Reo chemical wagon. In 1940, they had a Chevrolet panel truck adapted for use as a rescue wagon. By 1951, the organization became a two-engine company, and by 1957, the present firehouse on Nicholson Road was completed. (Courtesy of Edward Weber.)

In 1893 or 1894, Isabel M. Shipley of Camden founded a summer rest cottage in the Saddlertown community. The cottage was open for approximately two months in the summer and served as a country respite for the aged and infirmed. It was in existence for at least 20 years. The home was described as being across from the Rhoads Temple United Methodist Church. (Courtesy of Historical Society of Haddonfield.)

NINETEENTH
ANNUAL REPORT
—OF—
Rest Cottage
SADLERTOWN, N. J.
(P. O. HADDONFIELD)

SEASON 1913

A SUMMER HOME FOR AGED
——— AND ———
INFIRM COLORED PEOPLE

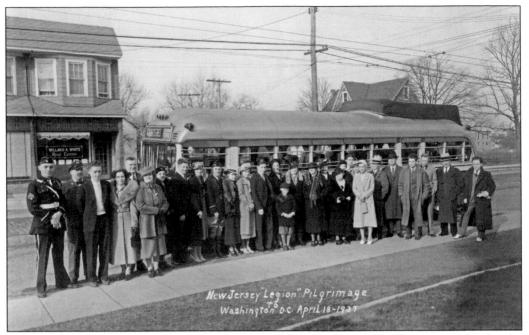

A group of American Legion members and spouses gathered in front of the Westmont School at the corner of Haddon and Reeve Avenues on April 18, 1937. Their destination was the annual American Legion national convention in Washington, DC. (Courtesy of William C. McKenna.)

A post office occupied the left side of this Haddon Avenue building. In 1910, Thomas L. Turton lived here with his wife, Anne Perkins Turton, daughter Eleanor, and sister-in-law Charlotte Perkins. Turton served as Haddon Township's postmaster. Turton, born in the British West Indies around 1866, was also employed as a painter and paperhanger. (Courtesy of Collingswood Public Library.)

In post–World War I years, the Westmont Loving Service was a volunteer organization that raised money for charitable and military veterans' causes, including the construction of war memorials. (Courtesy of William C. McKenna.)

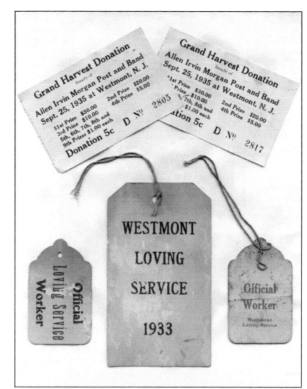

The local Bettlewood Fathers Association was established in the 1940s. They provided entertainment and events for neighborhood residents, including visits from Santa, gifts, spaghetti dinners, and carnivals. By the mid-1950s, they constructed the Bettlewood Fathers' Hall on Ormond Avenue, which became the primary location for many of their events. Here, some of the fathers that participated in a Christmas parade pose in front of Jennings School. (Courtesy of Jim Pharazyn.)

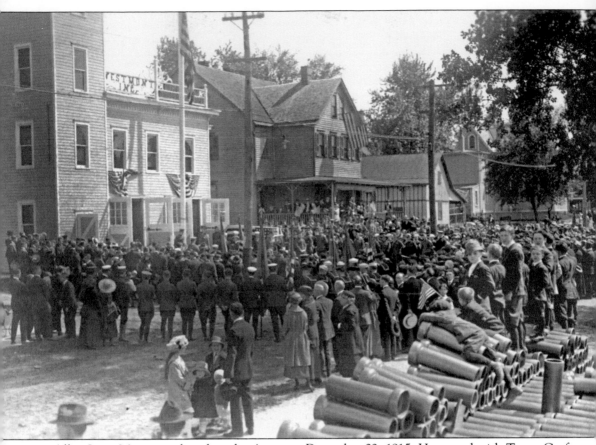

Allen Irvin Morgan enlisted in the Army on December 22, 1915. He served with Troop G of the 15th Cavalry Regiment. Cpl. Allen Irvin Morgan died March 22, 1918, at the age of 28 on a transport traveling to France. He was initially buried in France and then returned to the United States after the end of the war. Mourners gather at the Westmont Fire Hall on Center Street before Morgan's funeral. (Courtesy of William C. McKenna.)

Haddon Township's World War I memorial, commissioned in 1918, was created by renowned Illinois artist Richard W. Bock. It stands on a stone base containing the names of the 81 residents who served in the military during the war. The memorial was moved prior to the demolition of the Westmont School in 1961 and is now located at the Westmont Fire Company. (Courtesy of William G. Rohrer Memorial Library, Camden County Library System.)

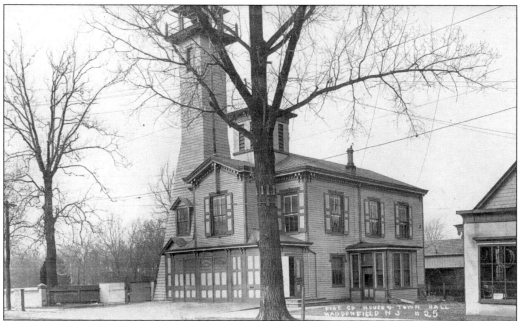

Haddon Township's first town hall was built in 1854 on Haddon Avenue near Kings Highway on the site of a Quaker meetinghouse demolished in 1851. It housed police and fire company equipment. Haddonfield remained part of Haddon Township until 1898. (Courtesy of Historical Society of Haddonfield.)

On January 16, 1951, the institution of the three-commissioner form of government in Haddon Township began with the inauguration of, from left to right, Eugene R. Catteau, William G. Rohrer, and J. Raymond Chard. (Courtesy of Haddon Township.)

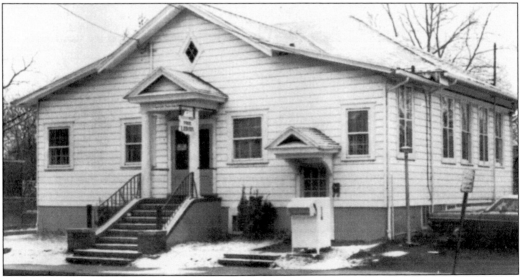

In 1926, Haddon Township set up a library stop of the new Camden County Library. It was located on Walter Stoy's property at 5½ Stoy Avenue, with Edith Proudfoot serving as librarian. In 1961, Haddon Township residents formed an association library that became a full branch of the Camden County Library System in 1975. For more than 30 years, it was located on Reeve Avenue, as seen in this image. (Courtesy of William B. Brahms.)

Seven

CHURCHES

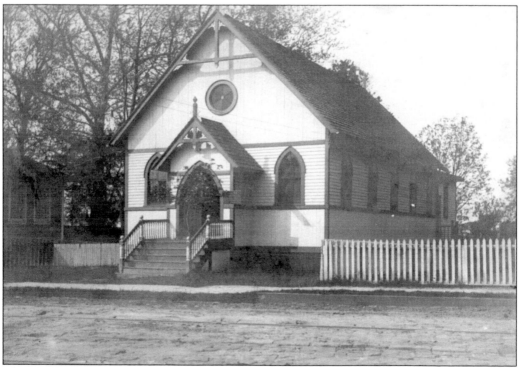

The First Baptist Church of Haddonfield instituted a mission Sunday school in Haddon Township in about 1880. In 1883, a church was organized under the name Shiloh Baptist Church. Shiloh Baptist was later disbanded, and in April 1896, Grace Baptist Church was organized. (Courtesy of Anne and Boyd Hitchner.)

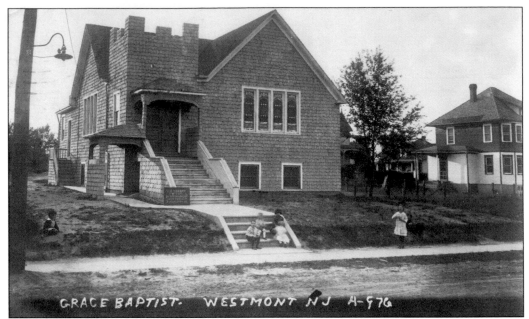

GRACE BAPTIST. WESTMONT NJ A-576

In April 1896, Grace Baptist Church was organized. In 1909, a lot on Reeve Avenue was purchased for $500. The cornerstone of the new Grace Baptist Church was laid in 1914. This photograph shows the church as it looked from 1915 to 1920. Grace Baptist Church continued to expand, and by 1969, the original church building was replaced by a new structure. (Courtesy of William G. Rohrer Memorial Library, Camden County Library System.)

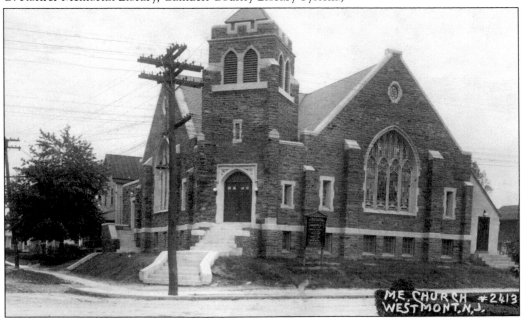

M.E. CHURCH #2413 WESTMONT. N.J.

In 1910, the Westmont Mission of the First Methodist Church of Collingswood ceased to exist and was renamed the First United Methodist Church of Westmont. In 1920, church trustees purchased a corner property at Center Street and Emerald Avenue. The new church was completed by 1923, and stained-glass windows were added around 1927. (Courtesy of William G. Rohrer Memorial Library, Camden County Library System.)

The Saddlertown community was founded on a 40-acre tract purchased in 1842 by Joshua Saddler. Joshua Saddler was a former slave from eastern Maryland. The Rhoads Temple United Methodist Church and School was completed in 1893. Land and construction expenses were paid for by Charles and Beulah Rhoads of Haddonfield, members of the Society of Friends. The school was located in the lower level of the building. (Courtesy of Myrna Blakely.)

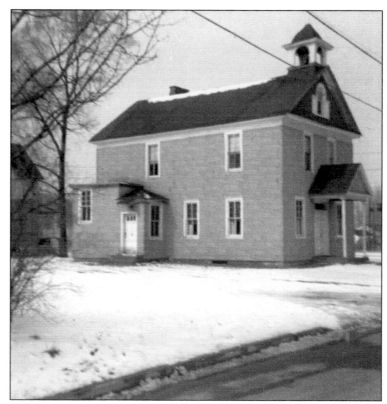

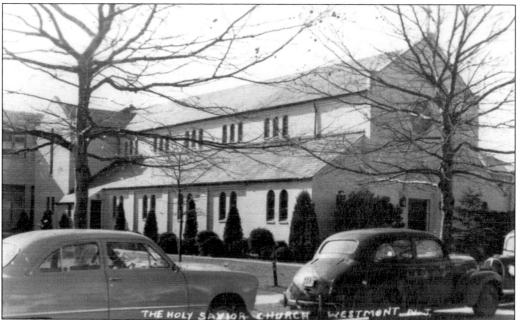

Holy Saviour parish was established in 1928. The first Mass was offered on Christmas Eve on the stage of the new Westmont Theatre. Sunday Mass was celebrated at the theater until a combination church/school building was completed. The new church was dedicated in 1941, and the rectory and convent were completed by 1948. (Courtesy of Stan Sheaffer.)

This is a 1909 view of the Newton Burial Ground, founded around 1682 as a cemetery for members of the Society of Friends. As was the tradition of the Society of Friends, there were no headstones to mark the grave sites. On the north side of the cemetery is a section named for James Sloan, dating from the 1790s, which contains the remains of those who did not follow the Quaker teachings. (Courtesy of Historical Society of Haddonfield.)

Calvary Baptist Church was founded by Reverend Bisgrove of Fairview and Reverend Hinch of Camden in 1935 as a community Sunday school and met at the West Collingswood Heights Fire Hall. In 1939, four building lots on Nicholson Road were purchased for $50. Ground breaking for the new church building took place on May 3, 1947. The cornerstone was installed on November 10, 1948. (Courtesy of Carol Schieber.)

Organized in 1926 as the First Methodist Episcopal Church of Oaklyn, ground breaking for the church at 21 East Cedar Avenue took place on August 13, 1928, on land purchased and given to the congregation by A. Moulton McNutt. In 1939, the name Emmanuel Methodist Church was adopted. The photograph shows the original church building. A new sanctuary was completed in 1962, with additional expansion occurring in 1968. (Courtesy of Emmanuel United Methodist Church.)

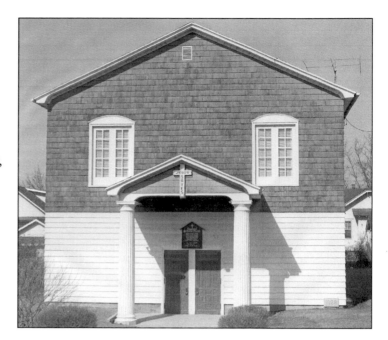

In 1953, Archbishop Damiano and Father Bernard Hewitt were assigned the task of creating a new parish. Five hundred families from five different neighboring parishes were selected to become members of the new St. Vincent Pallotti parish. Sunday Mass was celebrated at the Haddon Township High School auditorium. Ground breaking occurred on January 3, 1965, and by 1966, the new church and rectory were completed at 901 Hopkins Road. (Photograph by and courtesy of Mark Zeigler.)

DISCOVER THOUSANDS OF LOCAL HISTORY BOOKS FEATURING MILLIONS OF VINTAGE IMAGES

Arcadia Publishing, the leading local history publisher in the United States, is committed to making history accessible and meaningful through publishing books that celebrate and preserve the heritage of America's people and places.

Find more books like this at
www.arcadiapublishing.com

Search for your hometown history, your old stomping grounds, and even your favorite sports team.